CENTRE POMPIDOU

Musée National d'Art Moderne

Paintings and Sculptures

Jacinto Lageira

Centre Pompidou

EDITIONS
SCALA

The author would like to thank all those who have helped in the creation of this work, in particular Françoise Bertaux, Nathalie Leleu and Denys Riout.

Éditions Scala are grateful to Françoise Bertaux, publications manager of the Centre Pompidou, for her efficiency and readiness to help, France Sabary of the museum's photographic archive, and Evelyne Poniey of the documentation department.

The exhibition areas of the historical collections of the Musée National d'Art Moderne were refurbished with the support of Pierre Bergé, Yves Saint Laurent and the YvesSaintLaurent Company.

Front cover:
Yves Klein
Anthropometry of the Blue Period (Ant 82),
1960 (detail)

Graphic design:
★ Bronx (Paris)

Layout:
Thierry Renard

Translation:
Simon Knight

Copy-editing:
Bernard Wooding

Diffusion - Distribution :
CDE - Sodis

Contents

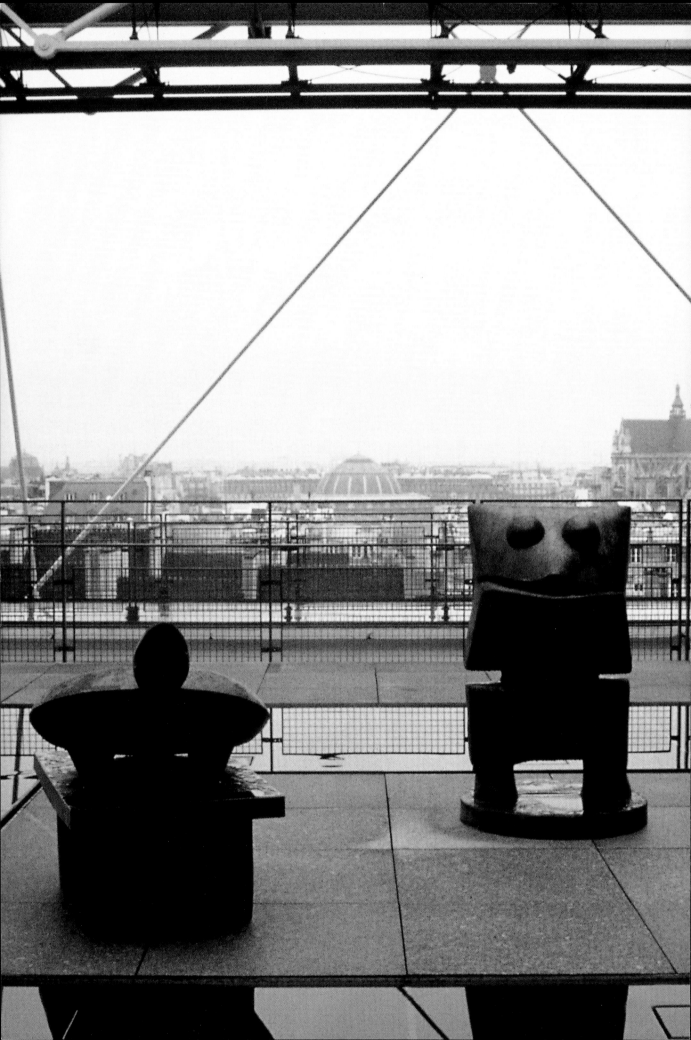

The MNAM
Collection Today

Now numbering some forty-five thousand works or items, the MNAM collections have been built up by stratification, accumulation and the interaction of various social and historical factors over a relatively short period of time. Barely half a century has passed since the Musée National d'Art Moderne was opened (at the Palais de Tokyo) in 1947. Though short, the museum's history has been eventful, including a change in venue in 1977, when the collections were moved to the Pompidou Centre. During the time it has been housed at the Centre, the museum was first restructured in 1986, to plans drawn up by Gae Aulenti.

Today, after a closure of two years during which the Pompidou Centre was completely refurbished, the permanent collection is displayed in accordance with a new, multi-disciplinary approach in exhibition areas enlarged and remodelled by the architect Jean-François Bodin. It now occupies two complete floors (fourteen thousand square metres, as against ten thousand previously) and features a selection of one thousand five hundred works covering all aspects of the visual arts in the 20th century (painting, sculpture, drawing, photography, the cinema and video). It also illustrates the links between these disciplines and architecture and contemporary design – two fields which came within the remit of the MNAM in 1992, when the museum merged with the Centre de Création Industrielle.

A look back over the history of the museum reveals that the collections were formed in three main stages, which roughly correspond with the three main methods of acquisition: donations and bequests, purchases, and donations in lieu of tax.

<
View of the west terrace,
Max Ernst
*The Big Turtle
and the Big Frog*
1967-1974

The Major Donations

During the first twenty years of its life, the MNAM's budget was relatively modest, only occasionally allowing the museum to purchase really important works. There were, however, a few exceptions: Francis Picabia's *Udnie* in 1949, Constantin Brancusi's *Le Coq* (*The Cockerel*) in 1947, Juan Gris's *Le Petit Déjeuner* (*The Breakfast*) also in 1947, and Picasso's stage curtain for *Parade* in 1955.

But most new acquisitions during this period were the result of donations or bequests, made possible by the generosity of artists and their families, and collectors and friends of the museum. Another important factor was the hard work of Jean Cassou, director of the MNAM at this time, who over many years had built up close and friendly relationships with the French art circles concerned.

These donations, especially those made by the artists themselves or their friends and families, provided the collection's real foundation, in the full sense of the word. They gave it its historical basis, and also its particular personality, which differs from that of comparable collections in other parts of the world. As far as the 20th century is concerned, neither the Tate Gallery in London nor the MOMA in New York owns groups of works of the same type: mini-collections which illustrate the entire career of an artist through studies, drawings and documentation (in addition to major works), virtually providing the material to reconstitute his or her studio.

It is not possible to mention all these donations, but the names include Picasso (eleven canvases, including the *Rocking-chair* [1943] in 1945), Chagall (seven paintings, including his *Double portrait au verre de vin / Double Portrait with Glass of Wine* [1917] in 1947) and Brancusi (who bequeathed the entire contents of his workshop in 1957), followed by Braque (1963), Laurens (1967), Rouault, Pevsner, Kupka, Gonzáles, Kandinsky and Delaunay among others.

The great collectors of the same generation also played their part. Special mention should be made of André Lefèvre in respect of Cubism, Raoul La Roche (four works by Braque), Baroness Gourgaud (*La Lecture / Reading* by Fernand Léger), Marie Cuttoli and Henri Laugier (who in 1963 donated a superb group of *papiers collés* by Picasso).

Thanks to these combined efforts, the collection began to take shape. By 1961 it already numbered over a thousand paintings and three hundred sculptures, but very few 'contemporary' works (i.e. from the 1950s) and almost nothing of American origin (the only exception being a sculpture by Calder).

A Targeted Purchasing Policy

In the 1970s, there was a growing awareness that the museum was falling behind in acquiring new works. While the project for the future Pompidou Centre was maturing, the state – at the instigation of President Pompidou, who was a connoisseur and admirer of modern and contemporary art – decided to become more involved and provide larger sums for purchasing new works. In 1975, the MNAM could rely for the first time on a substantial, independently managed budget, and the amount was doubled again in 1982.

Successive directors of the museum (Jean Leymarie from 1969 to 1973, Pontus Hulten from 1974 to 1981, Dominique Bozo from 1981 to 1986) were therefore able at last to embark on an ambitious purchasing policy, each with very definite objectives. Pontus Hulten's concern was to make up the deficiency in American art, Surrealism and international art generally. Dominique Bozo continued to consolidate and develop the Matisse, Miró, Giacometti, Dubuffet and Léger collections, concerned that France should retain essential aspects of its national heritage.

They played a very active role, and during this period many major works, including some outstanding masterpieces, were added to the historical collection. It would be tedious to list them all, but a few should be mentioned, in the order they were acquired: Derain, *Les Péniches / The Barges* [1906] in 1972; Dalí, *La Vache spectrale / The Spectral Cow* [1928] in 1974; de Chirico, *Portrait prémonitoire de Guillaume Apollinaire / Premonitory Portrait of Guillaume Apollinaire* [1914] in 1975; Matisse, *Le Violoniste à la fenêtre / Violinist at the Window* [1918] in 1975; Dubuffet, *Le Voyageur sans boussole / Traveller without a Compass* [1952] in 1976; Miró, *La Sieste / The Siesta* [1925] in 1977; Robert Delaunay, *Le Poète Philippe Soupault* [1922] in 1978;

Giacometti, *Portrait de Jean Genet* [1955] in 1980; Kirchner, *Toilette* [1913] in 1980; Klee, *Rythmisches / Rhythmus* [1930] in 1984, to name but a few.

At the same time, part of the budget was reserved for major contemporary purchases (*The Big Five* by Jasper Johns, *Métamatic no. 1* by Tinguely, *Le Magasin / The Store* by Ben, groups of works by Yves Klein and Martial Raysse). American art, so long ignored in Paris, found its way into the collections as a result of solidarity with the Pompidou Centre in the United States. The new acquisitions included *Oracle* by Rauschenberg, *Shining Forth* by Barnett Newman, and *Ghost Drum Set* by Oldenburg.

While stressing acquisitions through purchase, we should of course not forget the continuing support of the museum's major donors, in particular the Menil and Scaler Foundations (e.g. Malevich, *Black Cross*), and the loyalty of artists' families (in 1976 Nina Kandinsky gave the MNAM fifteen paintings by Kandinsky, including *Improvisation III* [1909] and *Mit dem Schwarzen Bogen / With the Black Arch* [1912]; the Lipchitz Foundation donated thirty-five of the sculptor's original plaster casts; Mme Jean Matisse contributed Henri Matisse's coloured-paper cut-outs for the Chapelle du Rosaire in Vence; and Mme Ida Chagall presented five major canvases by her father). A final mention should go to the donation made by Louise and Michel Leiris in 1984, which at a stroke added almost two hundred works to the museum, and greatly enhanced its collection of Cubist art.

Donation in Lieu of Taxation

In 1968 the French government introduced a special measure to ensure that major works were retained for the national collections – an arrangement whereby the heirs of artists and collectors were allowed to donate works of art in lieu of inheritance tax, provided of course that such works were considered as being of vital interest to the national heritage. The benefits of this measure – in the case of 20th-century art – began to be felt in the early 1980s. As a result, the museum was able to acquire a large part of the estates of artists (Chagall, Derain, Giacometti, Magnelli, Vieira da Silva, Dubuffet) and dealers, together with enlightened amateurs (Pierre Matisse, Robert Lebel, Alfred Richet). It has also added

masterpieces by Bonnard, Braque, Derain, Dubuffet, Duchamp, Giacometti, Klee, Laurens, Man Ray, Matisse and Miró to the historical collection.

Needless to say, the museum also continued to make purchases throughout this period, but these have become less frequent – as few as one or two a year – because of the spiralling prices being paid for sought-after works of art. It is worth mentioning the three-stage acquisition of *Bleu I*, *Bleu II* and *Bleu III* (1961) by Miró (in 1984, 1988 and 1993 respectively), Giacometti's *Femme égorgée / Woman with Her Throat Cut* (1932) in 1992, Fontana's *Concetto spaziale* (1949) in 1993, and Balthus's *Alice* (1933) in 1995.

The personal predilections of successive directors of the MNAM – Germain Viatte from 1993 to 1996 and Werner Spies from 1997 to 2000 – have of course influenced the acquisitions policy, as is evident, for example, from the purchases of works by Picabia, Dix, Schad and Oldenburg in recent years.

But there has also been a sustained determination to build up strong nuclei of contemporary works, representing Minimalism (based on Richard Serra), the Supports/Surfaces movement, Pop Art, Nouveau Réalisme, Arte Povera (of which the MNAM probably owns the best collection of any museum), Joseph Beuys, Gerhard Richter and so on. A special place has been accorded to large-scale installations and environments, from Dubuffet's *Jardin d'hiver / Winter Garden* (1970), to Beuys's *Plight* (1985) and Mike Kelley and Tony Oursler's video installation *The Poetic Project* (1977–97), donated in 1999 by the Friends of the museum.

Isabelle Monod-Fontaine
Assistant Director, MNAM

Emphasis on Colour
1905–1915: from the Fauves to the abstract movements

Because of the deep-rooted tradition of the image in Western art, painting was the focus of the first artistic revolutions of the early 20th century and the prime target of avant-garde artists.

Rules which had been systematised to the point of academic sterility by the end of the 19th century – in respect of copying, drawing, technique, modelling, perspective, the hierarchy of themes and genres – were brought crashing down. The aim was no longer to render the reality of the perceived world as faithfully as possible, but to leave more and more room for individual expression and to investigate the procedures and purposes of art itself. At the same time, artists began to develop some of the material possibilities of painting in terms of facture, technique and colour.

Colour had already been explored by the Impressionists, the Neo-Impressionists and the Symbolists, who had advocated its use in pure form, although this was not a rigid rule. With the Fauves, it became one of the formal elements which triggered profound changes in the aesthetics of painting. Indeed, it was because they used colours hitherto regarded as garish and violent that, at the Salon d'Automne in Paris in 1905, the artists exhibiting in room VII – who included Henri Matisse, André Derain and Maurice de Vlaminck – were

nicknamed 'fauves' (wild beasts). A work characteristic of the Fauvist period, Derain's *Faubourg de Collioure* (*Outskirts of Collioure*) shows the importance accorded to sharp colour contrasts and clearly visible brushwork. Even more than was the case for van Gogh or Gauguin, colour was no longer used to fill previously drawn outlines but became – to use Derain's expression – 'a parallel drawing'. It is true that their figures did sometimes have outlines, and their use of pure colours was not systematic, but by giving greater autonomy to colour, and seeing it as an end in itself, the Fauves bade farewell to naturalism and the slavish copying of external reality. Trees might be blue or hair orange; three-dimensional perspective was discarded; artists left their work deliberately unfinished, often with the canvas showing between the brushstrokes; they insisted on impasto effects and arbitrary processes became an integral part of their work. But it was colour which dominated and became in a sense the subject of the painting. The resulting technique was more spontaneous, forms tended to dissolve, and the deeply rooted concept of painting as an imitation of perceived reality was replaced by the idea of the picture as an autonomous artefact, its constituent elements laid bare for all to see.

During the short period the Fauves remained together as a group (1905–8), and though they had no established programme or style, their use of colour primarily as paint on canvas – in other words detached from the actual colours of the people and things they were supposed to be imitating – served to affirm the artificial nature of painting. This approach was defended by the painter and critic Maurice Denis, who wrote as follows in *L'Ermitage* in 1905: 'But what is particularly evident in Matisse is artifice; not literary artifice, as in a quest for idealistic expression; nor decorative artifice, as in the work of Turkish and Persian carpet-weavers; no, it is something still more abstract; it is painting outside all contingency, painting as an end in itself, the act of painting.' The use of colour to compose forms and space led to a considerable simplification of the painter's resources, giving them greater impact by making them independent of the motif and therefore better able to emphasise optical sensation and the artist's inner expression. This is why, in 1908, Matisse wrote in the

>
André Derain
Chatou, 1880 –
Chambourcy, 1954
Le Faubourg de Collioure
(Outskirts of Collioure)
1905

Oil on canvas
59.5 x 73.2 cm
Purchased 1966
AM 4367 P

Grande Revue: 'The dominant tendency of colour should be to serve expression as best as possible . . . My choice of colours is not based on any scientific theory: it is based on observation, on feeling, on the experience of my sensitivity . . . All I do is seek to apply colours which render my sensations.'

While the Fauves were causing a scandal at the Salon d'Automne, an association of young German artists, Die Brücke (The Bridge), was being founded in Dresden (it was officially dissolved in 1913 in Berlin). Gathered around Ernst Ludwig Kirchner, who drafted the group's brief manifesto, the artists of the first Expressionist wave (Fritz Bleyl, Erich Heckel, Karl Schmidt-Rottluff) were interested in the same genres as the Fauves (landscapes, nudes, portraits, still lifes). Like the Fauves, they drew

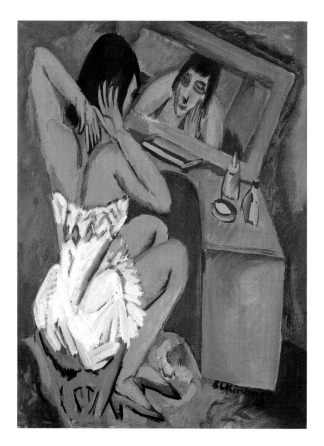

<
Ernst Ludwig Kirchner
Aschaffenburg, 1880 –
Frauenkirch, Davos, 1938
*Toilette – Frau vor
dem Spiegel
(Toilette – Woman
Before the Mirror)*
1912

Oil on canvas
100.5 x 75.5 cm
Purchased 1980
AM 1980-54

inspiration from African and Oceanic art, and also worked to renew the role of colour. However, they painted and sculpted with a brutality foreign to the Fauves, and their technique reflected the exuberant and disturbing quality of their work. They would sometimes dilute their paints with petrol, applying them with broad strokes of brush or palette knife, with the result that the canvas looked like an impasto mass thrown on at random. The artists of Die Brücke produced exaggerated deformations of their subject matter by sharply contrasting the figure with the background, creating distortions, and depicting faces and bodies as if they had been hewn with an axe. Despite the anguish or existential pain which seems to animate these angular figures with their clear, powerful lines (Kirchner, *Toilette*), the human being remained at the heart of Expressionist painting. As Kirchner himself affirmed: 'Art is made by man. His own person is the centre of all art, as his form and mass are the foundation and starting point of all sensation. That is why any teaching of the things of art must begin with man himself.'

>
Wassily Kandinsky
Moscow, 1866 –
Neuilly-sur-Seine, 1944
*Mit dem schwarzen Bogen
(With the Black Arch)*
1912

Oil on canvas
189 x 198 cm
Gift of Nina Kandinsky, 1976
AM 1976-852

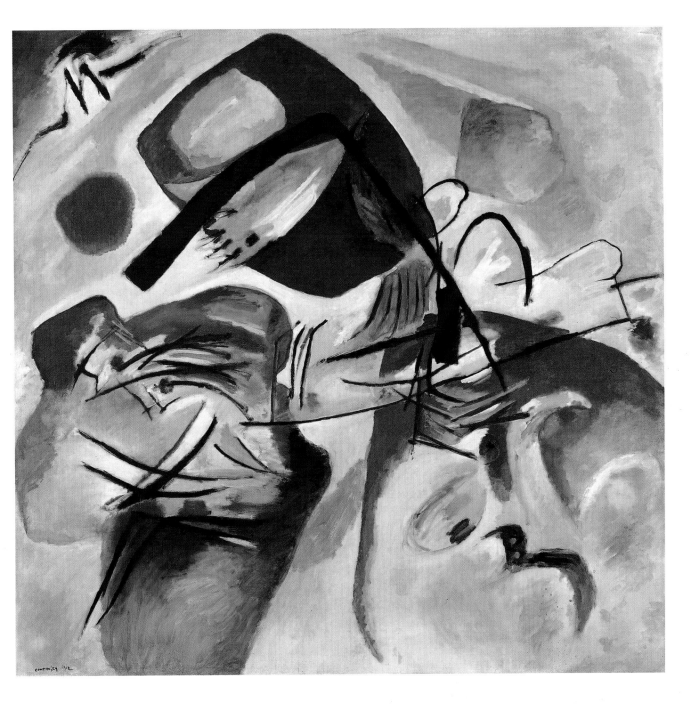

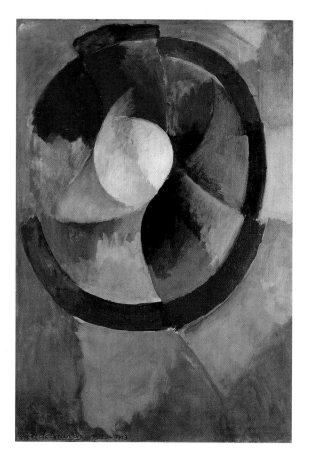

^
Robert Delaunay
Paris, 1885 – Montpellier, 1941
*Formes circulaires, soleil n° 2
(Circular Forms, Sun no. 2)*
1912–13

Glue painting on canvas
100 x 68.5 cm
*Gift of the Friends of the Musée National
d'Art Moderne, 1961*
AM 3910 P

>
Fernand Léger
Argentan, 1881 –
Gif-sur-Yvette, 1955
*Contrastes de formes
(Contrasts of Forms)*
1913

Oil on canvas
100 x 81 cm
*Gift of M. and Mme André
Lefèvre, 1952*
AM 3304 P

The second wave of Expressionism, Der Blaue Reiter (Blue Rider) movement, originated in Munich in 1911, at an exhibition at the Thannhauser gallery organised by Franz Marc and Wassily Kandinsky. Intellectually and artistically, the Blaue Reiter group (whose other members were Alexei von Jawlensky, August Macke, Gabriele Münter and Marianne von Werefkin) bore the stamp of Kandinsky, who had just finished his important essay *Concerning the Spiritual in Art* (published 1912). In this treatise, he developed two main ideas which were shared by the group as a whole: 'inner necessity' as the principle of the personal life of the artist which conditions his work; and the language of line and colour which must provide the pictorial response to this necessity. For Kandinsky, the artist 'can use any form to express himself' and must proceed in such a way that form is the 'exteriorisation of the inner content'. Although in the Blaue Reiter movement we still find some elements of Die Brücke – landscapes, houses, still lifes – the aim is no longer to rage at reality in images of overpowering candour, but on the contrary to escape from the material world into a spiritual realm attained by pure, eternal art. A consequence of this withdrawal from the material into a mystic dimension is that, as the Fauvist, Cubist or Futurist features melt away, the paintings produced by this group are notable for their shimmering colours, warm tones, soft outlines and harmonious compositions. The vividness of the colours, the strongly contrasting volumes they create and the tension between volume and outline were intended to stimulate a sensual synthesis which sets off a vibration in the observer's soul. To achieve this result, the Blaue Reiter artists conducted rigorous, formal research with the aim of establishing a universal pictorial language not limited by time or place.

In the second decade of the century, Kandinsky produced works which came close to pure abstraction (*Improvisation V*) or were entirely abstract (*With the Black Arch*), supposedly expressing nothing but the inner life of the artist freed of material attachments. At the same time, such disparate artists as Robert Delaunay (*Formes circulaires / Circular Forms*), František Kupka (*Ordonnance sur verticales / Order on Verticals*), Fernand Léger (*Contraste de formes / Contrasts of Forms*), Gino Severini

<

František Kupka
Opocno, 1871 – Puteaux, 1957
*Ordonnance sur verticales
(Order on Verticals)*
1911

Oil on canvas
58 x 72 cm
*Purchased 1957
AM 3562 P*

∨

Gino Severini
Cortona, 1883 – Paris, 1966
*La Danse de l'ours
au Moulin Rouge
(Dancing Bear at the
Moulin Rouge)*
1913

Oil on canvas
100 x 73.5 cm
*Purchased by the state, 1950
Attribution 1950
AM 2992 P*

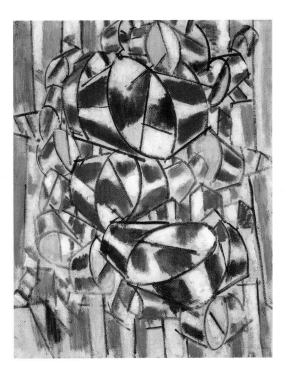

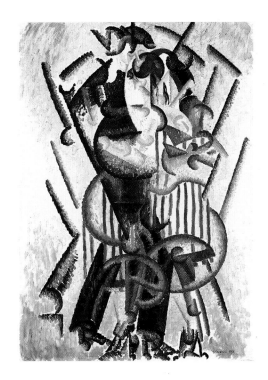

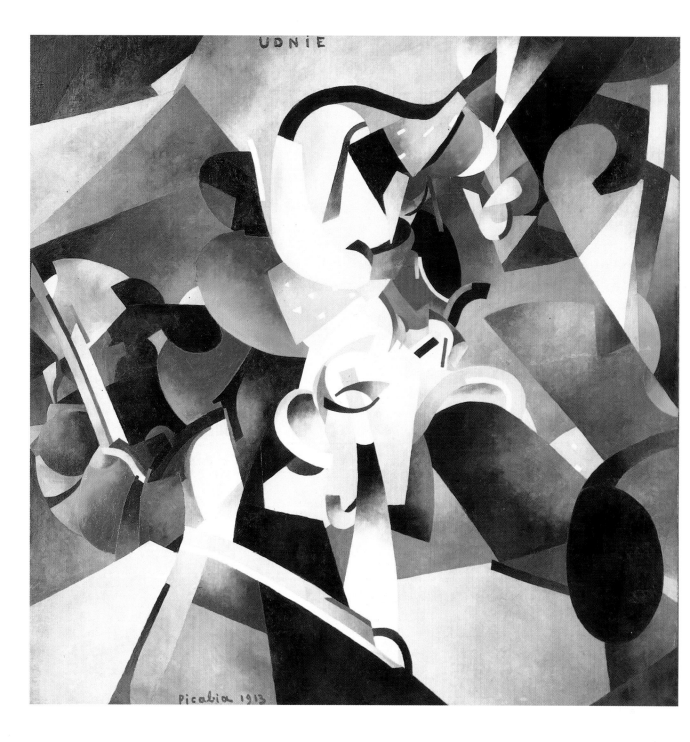

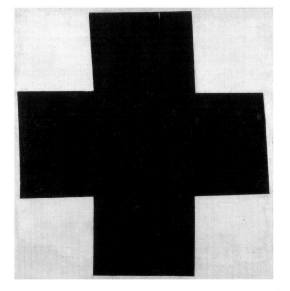

(*Dancing Bear*) and even Francis Picabia (*Udnie*) were experimenting with abstraction, giving free play to the interaction of colours on the canvas without reference to any aspect of exterior reality. Two main non-figurative tendencies, not always easy to distinguish, came to the fore at this time, one giving primacy to gesture, the other based on geometry. Colour was of course not the only issue that led to abstraction, but it was certainly one of the most decisive as artists refused to let it be enslaved to the long tradition of representation.

Kandinsky was the first artist to take this route when he affirmed that the role of art was to tend solely towards the ideal and to abandon materialism in all its forms. Despite their obvious formal differences, many abstract artists shared the desire to break free from reality as perceived by the senses, to transcend it. This is certainly true of Kupka and Mondrian, and also of Malevich (*Black Cross*). These painters were of course exercised by the problems of their medium, but they sometimes went as far as to minimise the material importance of painting, seeing it merely as the means of access to a world beyond appearances. This sort of position was not defended by artists such as Delaunay or Léger, who were interested mainly in the physical constituents of painting and its optical effects. But, generally speaking, the fundamental issue for abstract artists was whether painting was essentially connected with imitation, or whether it could depend on its inherent qualities alone. As a consequence of the non-referential organisation of plastic elements – lines, colours, volumes, blotches, textures – for the first time in the history of Western art artists were not painting with a view to imitation. They were not copying anything found in the real world.

∧
Kasimir Malevich
Kiev, 1878 – Leningrad, 1935
Black Cross
1915

Oil on canvas
80 x 79.5 cm
Gift of the Scaler Foundation and the Beaubourg Foundation, 1980
AM 1980-1

<
Francis Picabia
Paris, 1879 – 1953
Udnie
1913

Oil on canvas
290 x 300 cm
Purchased by the state, 1949
Attribution 1949
AM 2874 P

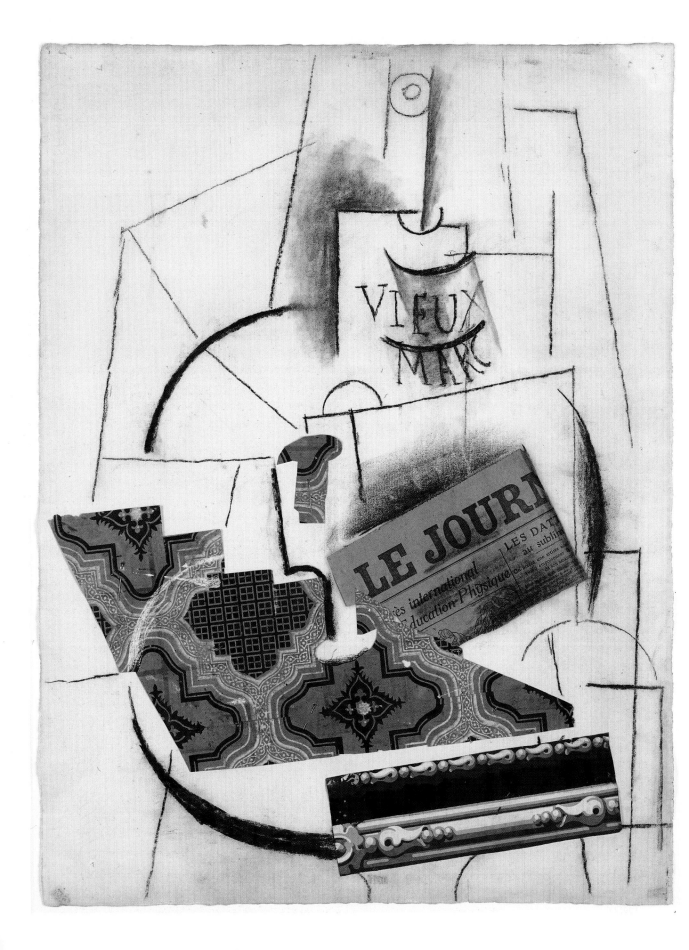

Matter, Object, Material
1908–1920: from Cubism to Constructivism

A few useful distinctions concerning the use of matters, objects, and materials, together with their concepts.

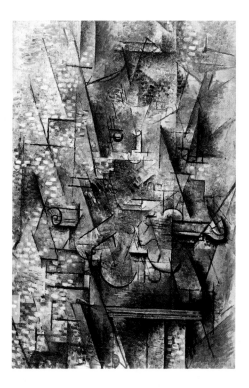

<
Pablo Picasso
Malaga, 1881 –
Mougins, 1971
Bouteille de vieux marc
(Bottle of Vieux Marc)
1913

Charcoal, pieces of paper
pasted and pinned to paper
63 x 49 cm
Gift of Henri Laugier, 1963
AM 2917 D

∧
Georges Braque
Argenteuil-sur-Seine, 1882 –
Paris, 1963
Nature morte au violon
(Still Life with Violin)
1911

Oil on canvas
130 x 89 cm
Gift of Mme Georges Braque,
1963
AM 4299 P

Although there is no doubt that Picasso's *Demoiselles d'Avignon* (1907, MOMA, New York) was instrumental in the formulation of the new stylistic language that came to be known as 'Cubism' (a term first used in 1911), the trend first came to public attention at an exhibition of works by Braque at the Kahnweiler gallery in Paris in 1908. Writing about Braque's latest canvases of landscapes at L'Estaque, one critic pejoratively noted that the artist 'reduces everything, places and figures and houses, to geometrical schemas, or cubes.' Though unappreciative, he had vaguely grasped what was to become one of the key aspects of Braque and Picasso's joint endeavours between 1907 and 1914: *construction*. Experimenting with geometrical reductions and structures, cut-outs and fragmentation, lines and facets, during this period the two friends redefined the human figure and completely disposed of the laws of perspective, which had dominated pictorial composition since the Renaissance. Their approach was magnificently formulated by Apollinaire in 1913: 'Cubism is the art of painting new compositions with elements borrowed not from the reality of vision, but from the reality of conception'. This concept depended essentially on grasping the different components of the object or person observed (thickness, volume, texture, transparency) – components not evident from a frontal view, which in any case does not exist in reality. By rendering various facets of an object in one and the same painting (Braque, *Nature morte au violon / Still Life with Violin*, 1911 and *Compotier et cartes / Fruit Dish and Cards*, 1913; Picasso,

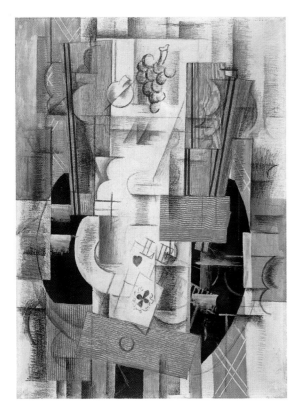

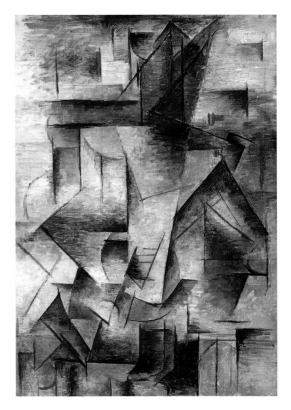

∧
Georges Braque
Argenteuil-sur-Seine, 1882 –
Paris, 1963
Compotier et cartes
(Fruit Dish and Cards)
1913

Oil, pencil and charcoal
on canvas
81 x 60 cm
Gift of Paul Rosenberg, 1947
AM 2071 P

∧ ∧
Pablo Picasso
Malaga, 1881 – Mougins, 1971
Le Guitariste
(The Guitarist)
1910

Oil on canvas
100 x 73 cm
Gift of Jeanne and André Lefèvre,
1952
AM 3970 P

Le Guitariste / The Guitarist, 1910), the Cubists aimed to give a fragmentary, bit-by-bit vision of it. But, having apparently broken the world down into countless pieces, they recomposed the multiplicity of the visible into a single image. By bringing together both front and rear view, 'folding' planes and making them turn, introducing multiple points of view, exaggerating lines, edges and the graduated transitions between the facets of an object or body, they gave their paintings a *sculptural* quality. This shift from the sculptural to the pictorial, or from the three-dimensional to the flat, was also due to the influence of African sculpture, which is devoid of mimetic intention. In both cases, the aim was not to copy but to conceive a reality different from that which is perceived naturally. In Braque and Picasso's Cubism, the vision is no longer founded on the evidence of sensation alone but derives from a conceptual grasp of reality.

In May 1912, Picasso produced his first 'collage', *Nature morte à la chaise cannée (Still Life with Chair Caning,* Musée Picasso) – featuring a piece of oilcloth printed to resemble chair caning, with a piece of rope for a frame –

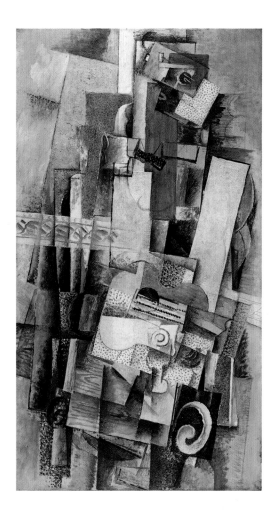

and, in September of the same year, Braque completed his first 'papier collé' (paper collage), *Compotier et verre* (*Fruit Dish and Glass*), including three strips of wallpaper imitating wood. For the first time in the history of painting, concrete elements were incorporated into the picture, existing as themselves, giving rise to both optical and tactile sensations. As fragments of external reality, the pasted pieces of paper made the canvas itself a fragment of reality. The painting was no longer a mere image, since it became a piece of tangible reality – what Braque and Picasso called a 'tableau objet' (picture object). Used just as they were, with their colour, texture, density or lightness, the pasted pieces of paper drew the viewer's attention as much to their materiality as to their properties as expressive plastic materials. However, this did not mean that the illusion of reality was totally dissolved, as charcoal lines might be added to the pieces of paper – giving the illusion, for example, that a transparent object was placed in front of them – or they might be used to imitate a completely different material, as in *Bouteille de vieux marc* (*Bottle of Vieux Marc*, 1913), to the canvas of which Picasso pinned a strip of paper in imitation of a fragment of metal frame. The visual, tactile and mental paradox derives from the fact that the pasted pieces of paper, while sometimes giving the illusion of being something else, remain identifiable as the pieces of paper they are. Cubism was profoundly realistic in its use, for both painting and sculpture (e.g. Picasso's sculptures or Laurens's *Bouteille et verre* / *Bottle and Glass*), of relatively easily recognisable materials, such as newsprint, old pieces of wood, plaster, fabric trimmings, wire, sheet metal, cardboard, sand or sawdust mixed with paint (Braque, *L'homme à la guitare* / *Man with Guitar*). It thus paved the way for the object as an autonomous entity and for the use of materials for their own sake.

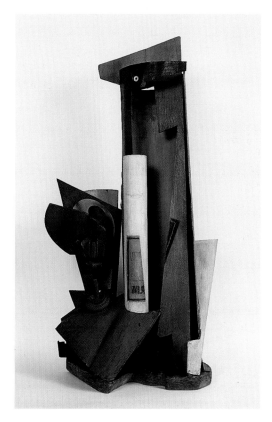

∧
Georges Braque
Argenteuil-sur-Seine,1882 –
Paris, 1963
L'Homme à la guitare
(Man with Guitar)
1914

Oil and sawdust on canvas
130 x 72.5 cm
Purchased with a special state
loan and help from the Scaler
Foundation, 1981
AM 1981-540

>
Henri Laurens
Paris, 1896 – 1954
Bouteille et verre
(Bottle and Glass)
1918

Wood and polychrome
sheet metal
62 x 34 x 21 cm
Gift of Louise and
Michel Leiris, 1984
AM 1984-569

Even though the works they produced in 1912–13 were not widely known at the time, there is no doubt that Braque and Picasso's repeated acts of daring prepared the ground for Marcel Duchamp to elevate an everyday object to the status of work of art. A painter who had formerly been associated with the Cubist and Futurist tendencies, in 1913 Duchamp had the idea – ludicrous in some people's minds, but logical as a continuation of the pioneering gestures of Braque and Picasso – of focusing on the object to the exclusion of any other element which might relate it to painting or sculpture. So he produced *Roue de bicyclette* (*Bicycle Wheel*) – an ordinary wheel with the upturned forks mounted on a kitchen stool – and at about the same time wrote a note asking: 'Can one create works which are not "art"?' This bizarre object was followed in 1914 by *Porte-bouteilles* (*Bottle Rack*), an ordinary bottle rack bought from a department store. These objects were left in Duchamp's Paris studio when he left for the United States in 1915. Once in America, he repeated his gesture, this time exhibiting a snow shovel with the title *In Advance of the Broken Arm*. He referred to it as a 'ready-made', a term he continued to use for other art objects and actions of this kind. As Duchamp himself explained, these everyday objects should not have anything to do with aesthetic pleasure: 'The choice of ready-mades is always based on visual indifference at the same time as a total absence of good or bad taste.' Rejecting any kind of technique, Duchamp also spoke of a 'mental choice' or 'pictorial nominalism', by which he was referring to the possibility of divorcing an object from its context and function, and giving it the status of a work of art purely on the strength of the artist's designation. Although there may have been a large element of provocation and mischievous humour in Duchamp's gesture, it nevertheless raised a whole series of artistic and aesthetic issues which still exercise us today. What is a work of art? What is art? Who decides? When and according to what criteria does an object become a work of art? Although Duchamp did far more than produce ready-mades, his introduction of real objects into the world of art was one of the most cataclysmic acts in 20th-century art.

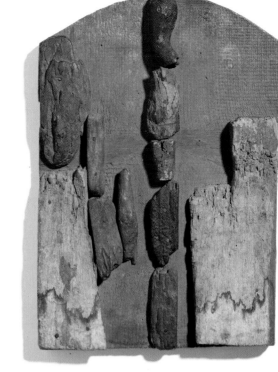

<
Marcel Duchamp
Blainville, 1887 – New York, 1968
*Roue de bicyclette
(Bicycle Wheel)*
1913/1964

Ready-made
Metal, painted wood
126.5 x 31.5 x 63.5 cm
Purchased 1986
AM 1986-286

>
Hans Arp
Strasbourg, 1886 – Basle, 1966
Trousse d'un Da
1920–21

Assemblage
Driftwood nailed to wood
and partly painted
38.7 x 274.5 cm
*Gift of M. and Mme Christophe
Tzara, 1989*
AM 1989-195

<
Marcel Duchamp
Blainville,1887 – New York, 1968
In Advance of the Broken Arm
1915

Wood and galvanised iron
132 x 65 cm
Purchased 1986
AM 1986-289

>
Raoul Hausmann
Vienna, 1886 – Limoges, 1971
*Der Geist unserer Zeit –
Mechanischer Kopf
(The Spirit of our Time –
Mechanical Head)*
1919

Wooden dummy
and other objects
32.5 x 21 x 20 cm
Purchased 1974
AM 1974-6

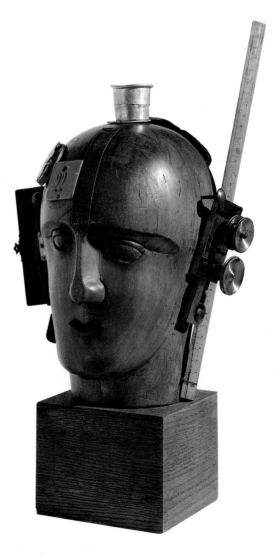

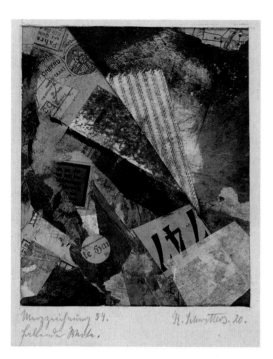

The Dada group – the name was picked at random from a dictionary and retained because of its many possible connotations – was founded on 5 February 1916 and originally included the poets Hugo Ball, Tristan Tzara and Richard Huelsenbeck, and the painters and sculptors Marcel Janco, Hans Richter, Christian Schad, Hans Arp and Sophie Taeuber. They were rebelling against art and the established order, and appealing to the irrational. They disseminated their ideas at 'Dada evenings' held at the Cabaret Voltaire, where poets and painters recited poems and staged musical, drama and ballet performances, all deliberately outrageous and calculated to cause scandal. Dadaism spread to many other parts of Europe and the United States, and artists continued to put on events and exhibitions which ridiculed traditional artistic categories, mainly by employing incongruous elements. In their use of materials of little intrinsic value – plaster, embroidery, cardboard, torn-up paper, driftwood (Hans Arp, *Trousse d'un Da*) – the adoption of such

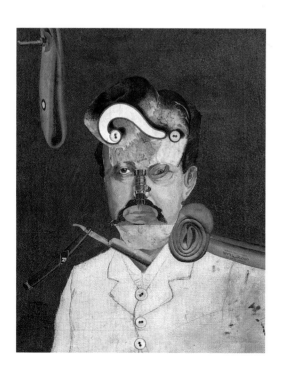

∧
Kurt Schwitters
Hanover, 1887 – Ambleside 1948
*Merzzeichnung 54. Fallende Werte
(Merz Drawing 54. Falling Securities)*
1920

Watercolour, different kinds of paper
and fabric pasted on paper
30 x 22.5 cm
Purchased 1995
AM 1995-203

<
George Grosz
Berlin, 1893 –1959
*Remember Uncle August,
the Unhappy Inventor*
1919

Oil, pencil, paper and buttons
glued on canvas
49 x 39.5 cm
Purchased 1977
AM 1977-562

v
Man Ray
Philadelphia, 1890 – Paris, 1976
Lampshade
1919/1954

Painted aluminium
152.5 x 63.5 cm
Given in lieu of inheritance tax 1994
AM 1994-300

>
Sophie Taeuber-Arp
Davos, 1889 – Zurich, 1943
Tête
(Head)
1918–19

Painted wood
34 x 20 x 20 cm
Gift of Marguerite Arp-
Hagenbach, 1967
AM 1692 S

techniques as assemblage (Raoul Hausmann, *L'Esprit de notre temps / The Spirit of Our Time*), collage (Kurt Schwitters, *Merzzeichnung 54 / Merz Drawing 54*) and photomontage (Georg Grosz, *Remember Uncle August, the Unhappy Inventor*), and their subversion of objects and creation of unusual forms (Man Ray, *Lampshade*; Sophie Taeuber-Arp, *Tête / Head*), the Dadaists made an important contribution to broadening the notion of artistic materials. The main characteristic of Dadaist materials was that they were basically junk, retaining traces of their origins even if they were transmuted into collages or assemblages in which they played an expressive role. In works of art, scrap materials, or materials regarded as mediocre or non-artistic (advertisements, posters, photographs, illustrated magazines, children's books, medical encyclopedias, etc.), as in Max Ernst's collages (*La Femme 100 têtes / The 100 Headless Woman*), were deliberately used to blur the aesthetic frontiers between 'great art' and popular culture.

∧
Max Ernst
Brühl, 1891 – Paris, 1976
*Collage for La Femme
100 têtes (The 100 Headless
Woman), chap. 4,
'Son sourire, le feu, tombera
sous forme de gelée noire
et de rouille blanche sur
les flancs de la montagne'
(Her smile, the fire, will
fall as black frost and
white rust on the slopes
of the mountain)*
1929

19.5 x 14.5 cm
Gift of Carlo Perrone, 1999
AM 1999-3 (24)

>
Antoine Pevsner
Oryol, 1886 – Paris, 1962
*Construction dans l'espace
(Construction in Space)*
1923–25

Bronze and crystal
64 x 84 x 70 cm
Gift of Mme Pevsner, 1962
AM 1346 S

Apart from Duchamp, the work of Cubists and Dadaists hinged on the question of what could and could not be admitted to the rank of artistic material, and why. In this respect, Dada proved bolder in mixing media: everything could be used as matter and material for art. Another, more theoretical, route was taken by the Russian avant-garde, which, emboldened by Cubism and Italian Futurism, played a fundamental role in defining thinking on pictorial and sculptural materials. During the 1910s and 1920s, the Russians actively engaged in practical and theoretical work on materials or, more exactly, on what they preferred to call *faktura* (facture). Concerned with surface workmanship, as well as the texture and reflection, transparency, mass and luminosity of a material, facture was a development of the idea that aesthetic values are not determined by a pre-existing form but are relative to the raw material, the specificity of which conditions the process of constructing the work and the way it is perceived. The material is worked on and exhibited for its own sake, just as it is. For instance, Antoine Pevsner's *Construction dans l'espace* (*Construction in Space*) plays on the ideas of opacity and transparency, lightness and weight, using materials which were new to the sculpture of the period.

The Dissemination of Language
1911–1930: from Cubism to Surrealism

When, in 1911, Braque stencilled some words and letters on a painting entitled *Le Portugais (The Portuguese)*, he was trying to reintroduce a realism that was tending to disappear from Cubism at the time. Cubist works had become so fragmented that the image as a whole was difficult to decipher.

<
Pablo Picasso
Malaga, 1881 – Mougins, 1971
*Tête d'homme au chapeau
(Man Wearing a Hat)*
1912-13

Charcoal, gouache, sand and
papier collé on paper
65 x 49.5 cm
*Gift of Henri Laugier, 1963
AM 2916 D*

∧
Georges Braque
Argenteuil-sur-Seine, 1882 –
Paris, 1963
*Nature morte sur la table
(Still Life on a Table)*
1914

Charcoal, papier collé on paper
48 x 62 cm
*Given in lieu of inheritance
tax 1984
AM 1984-354*

The idea was quickly taken up by Picasso. Both artists incorporated letters and words, painted or cut from newspapers or magazines, the main function of which was to anchor the viewer's gaze in the picture and provide an element of stability, while allowing them to pursue their research into matters of form, such as the relationship between volumes and flat surfaces. According to Braque, words and letters were perfectly suited to this purpose: 'They were forms in which there was nothing to deform because, being flat components, letters were outside of three-dimensional space and their presence in the picture, by contrast, made it possible to distinguish between objects situated in space from those outside space' (Braque, *Nature morte sur une table, 'Gillette' / Still Life on a Table, 'Gillette'*). This brings us back to the idea that the canvas is above all an 'object' to which the artist applies all sorts of elements alien to traditional painting, but with the difference in this case that the letters, words or, sometimes, a complete newspaper article (Picasso, *Tête d'homme au chapeau / Man Wearing a Hat*) were also *to be read*. For the wording sometimes had an immediate relationship with the canvas as a whole. The fact that words in the Cubism of Braque or Picasso have a decorative or expressive value, a realistic or plastic character, should not obscure their true linguistic aspect. According to its primary definition, a word stands in the place of the thing which it

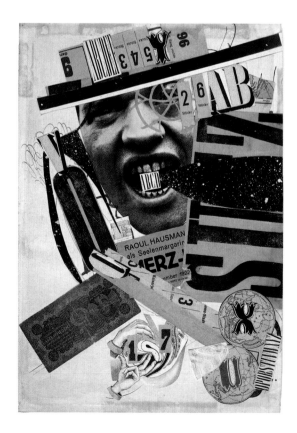

designates, without of course being the thing itself. A page from a newspaper is of course a 'papier collé', but it is also a text which speaks of entities not visible or palpably present in the picture. But whether painted or pasted on, letters, words and texts were understood by Braque and Picasso to be both raw material and abstract language, sharing the same fate as the other fragmented elements of the canvas, while retaining the meanings inherent in language alone, which were sometimes incomplete, if not totally lost.

The material explosion of language and the dissemination of meaning proposed by the Cubists led the Italian Futurists to what was defined in 1913 by Marinetti as 'parole in libertà', i.e. words set free from any concrete link with punctuation or layout on page or canvas, free of any kind of format, colour or direction. Building on these developments, the Dadaists carried things to a logical extreme and claimed as their own the realm of nonsense. Of course, they maintained the equivalence between plastic and linguistic materials, and this is clearly evident if we compare the collages produced by Hans Arp and Sophie Taeuber-Arp around 1915, in which the positions of the pieces of paper were left entirely to chance, with the recipe for a Dadaist poem issued by Tristan Tzara in 1920: 'To make a Dadaist poem. Take a newspaper. Take a pair of scissors. Select from the newspaper an article of the length you intend your poem to be. Cut out the article. Then carefully cut out each of the words of the article and put them in a bag. Shake gently. Then draw out the clippings, one after another. Conscientiously copy them in the order they emerge from the bag. The poem will be like you.'

The principles of chaos, disorder and the random organisation of materials were applied to works involving language, which seemed to disintegrate, run out of control and lapse into pure nonsense. Just as Dadaist materials respected no hierarchy of values or composition, language too had to take part in these apparently incoherent and meaningless procedures. Photomontage, painting, poetry and sculpture were governed by the only law the Dadaists recognised as being valid: being anti-Dada. If we try to interpret – as one might a word

∧
Raoul Hausmann
Vienna, 1886 –
Limoges, 1971
OFF
1918

Typography on green paper
32.5 x 47.5 cm
Purchased 1974
AM 1974-7

∨
Raoul Hausmann
Vienna, 1886 – Limoges, 1971
ABCD Portrait de l'artiste
ABCD (Portrait of the Artist)
1923–24

Collage
India ink, photographic
reproduction and printed matter
cut out and pasted onto paper
40.4 x 28.2 cm
Purchased 1974
AM 1974-9

Joan Miró
Barcelona, 1893 – Palma
(Majorca), 1983
L'Addition
(The Bill)
1925

Oil on glued canvas
195 x 129.2 cm
Purchased 1982
AM 1983–92

Joan Miró
Barcelona, 1893 – Palma
(Majorca), 1983
La Sieste
(The Siesta)
1925

Oil on canvas
113 x 146 cm
Purchased 1977
AM 1977-203

or sentence – Raoul Hausmann's 'poster-poem' *OFF* (1918), the letters seem scrambled and nonsensical, and so do not lend themselves to reading. And yet, their order and the position of each letter seem to suggest that they are intended to be read, from left to right. Are they therefore to be viewed and perceived as an image for their purely plastic value and typographical beauty, or as a text? The small hand symbol pointing to the bottom of the page – a familiar device of printers or advertisers – is placed in sequence with the other letters, although it is really a drawing. But though a pointer, and as such a drawing, it is also an almost verbal sign in a succession of other signs. Although it does not punctuate the sequence of letters in a verbal way, it seems to punctuate the visual space and the organisation of the whole. The photomontage *ABCD*, in which Hausmann's face also features, illustrates another aspect of Dadaist work on language, directly connected with visual perceptions of poster-poems or paintings including language: they are to be read, looked at and *spoken out loud*. This third requirement explains why, in *ABCD*, letters are depicted issuing from Hausmann's mouth. This kind of optical and linguistic experimentation on the part of the Dadaists can be summed up in the celebrated dictum of Tristan Tzara: 'Thought is performed in the mouth.'

Irreverent, and apparently just as absurd, Francis Picabia's attitude to language – adopted before Dadaism, but reflecting Dadaist concerns – was typical of a determination to destroy the sense of reason which sees itself, wrongly according to the adherents of Dada, as sensible and reasonable. When he juxtaposed words and machines, as if the latter were word machines generating text without any purpose or any precise information to convey, he introduced a language divorced from thought. While apparently causing words to function, the machines seem at the same time to scramble and destroy them, making language mechanical. The texts written in *Chapeau de paille (Straw Hat)* and *Portrait de Marie Laurencin* are just going through the motions, like the machine. But the machine, like the words that issue from it, though they

have no immediate sense or hidden meaning to be
deciphered, at least conveys a story. Or rather, it is a cog
of history. Producing *senseless* paintings of this kind
during or after the debacle of the Great War was not so
much a matter of emphasising the loss of all values or
creating new ones, but rather affirming the simple fact of
existing, of still being. The texts are not defeatist, but on
the contrary advocate a life-saving sense of humour and
laughter. To the adage 'That which is well conceived
comes across clearly', one could reply with Hans Arp's
formula: 'Dada wanted to replace the logical non-sense
of the men of today with an illogical without-sense'.

**Although during his Dada period, beginning in 1912,
Max Ernst had become familiar with Freud's writings
and produced collages based on associations of ideas
and dream formulations, it was not until 1924 that
this influence was officially acknowledged by the
Surrealists.** The fact is that their approach to words in
the plastic arts derived essentially from the unconscious
procedures analysed by Freud in *The Interpretation of
Dreams* (1900). Surrealist works function as in dreams
described by the psychoanalyst: either as images, which
one then attempts to verbalise, or as words and phrases,
from which an increasingly clear overall picture can be
derived. So Surrealism sought to give account of a kind
of spoken thought, thought expressed in images and by
images. The method of the 'cadavre exquis' (exquisite
corpse) was the model for this procedure: the technique
was to write a few words on a sheet of paper, fold it so
that only the end of the sentence was visible, pass it to a
neighbour so that he could add his contribution to the
text, and so on. This method was also applied to visual
'poems', produced by drawing or by collage. For, in the
eyes of most of the Surrealists, there was no difference
between poetry and painting, as Joan Miró
acknowledged in a series of paintings featuring words or
complete sentences, to which he gave the generic name
of 'tableaux-poèmes', or poem pictures (*La Sieste*).

But it was undoubtedly René Magritte who, during
the 1920s, pushed experimentation with the relationship
between words and images to its furthest extreme.

>
René Magritte
Lessines, 1898 –
Brussels, 1967
*Querelle des universaux
(The Dispute about Universals)*
1928

Oil on canvas
53.5 x 72.5 cm
Purchased 1993
AM 1993-116

Playing on the conventions of language in relation to the things named and perceived, Magritte ran through almost all the possibilities provided by their juxtaposition on the canvas. For him, 'a word can take the place of an object in the real world', 'an image can take the place of a word in a proposition', or 'an object never serves the same function as its name or image'. The title of his humorous *Querelle des universaux* (*Dispute about Universals*) refers to a philosophical debate which began in ancient Greece and reached its height in the Middle Ages. The question was whether the name of a thing applied only to an individual example of that thing or also to things in the plural.

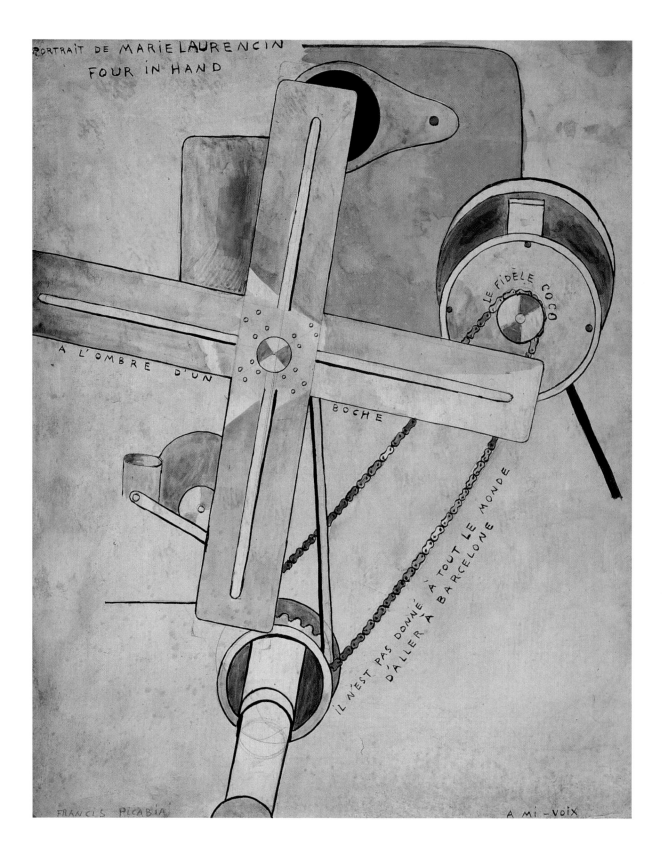

<
Francis Picabia
Paris, 1879 – 1953
Portrait de Marie Laurencin
(Portrait of Marie Laurencin)
1916–17

India ink, pencil, gouache and
watercolour on cardboard
56 x 45.5 cm
Gift of Juan Alvarez de Toledo, 1990
AM 1990-258

v
Francis Picabia
Paris, 1879 – 1953
Chapeau de paille ?
(Straw Hat?)
c. 1921

Oil and collage on canvas
92.3 x 73.5 cm
Bequest of Dr Robert Le
Masle, 1974
AM 1974-110

^
Jacques de la Villeglé
Quimper, 1926
Tapis Maillot
(Maillot Carpet)
1959

Torn posters glued to canvas
118 x 490 cm
Purchased 1974
Attribution 1980
AM 1980-428

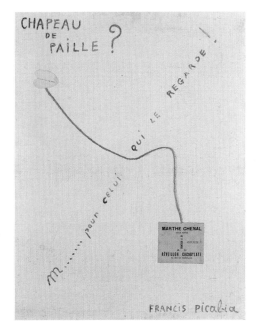

Despite their divergences, these movements had understood that, even if words and letters were deconstructed, cut up, or shown only in part, their meaning could not be eliminated, and that for this very reason the viewer was trapped by the fact of language. Although he might understand nothing of the images perceived, he could not escape (whether or not he was attracted by the picture) from the word or letter, as if the work triggered in him a reflex action obliging him to read. In other words, language was not just another material, for whereas facture belonged in the final analysis to the field of painting, writing was also to be understood as the raw material of language and not just as part of the pictorial field. Finally, the fact that artists had not wanted to draw their vocabulary from professional jargon or erudite terminology, be it literary, sociological or philosophical, demonstrated another aspect of language: its democratisation. This characteristic is to be found later in the torn posters of Jacques de la Villeglé (*Tapis Maillot / Maillot Carpet*). Words do not belong to the language of an élite, but to society as a whole, to us all.

A Utopian View
of People and Objects
1916–1933: from Dada
to the Bauhaus

It is widely held that the fundamental changes in human history have occurred in the fields of science or politics, not in the realm of art.

<
Vladimir Tatlin
Kharkov, 1885 –
Moscow, 1956
*Model for the Monument
to the Third International*
1919/1979

Wood and metal
500 cm
Purchased 1979
AM 1979-413

∧
Theo van Doesburg
Utrecht, 1883 – Davos, 1931
Peinture pure
(Pure Painting)
1920

Oil on canvas
130 x 80.5 cm
Purchased 1964
AM 4281 P

Nevertheless, the avant-garde movements which emerged during or shortly after the First World War also set out to change the world, despite the terrible setback represented by the war itself. It was no doubt the determination to arrive at what avant-garde artists referred to as the 'new man' that explains the persistence of Utopian projects. These include the Dutch De Stijl (The Style) group founded in 1917, the Bauhaus school, opened in Weimar in 1919, and Russian Constructivism, which began to take shape in 1920. Rooted in the abstract art movement, despite their differences in matters of art theory and ideology, these three streams shared a common interest in achieving a synthesis of the arts and in the idea that their creative work could and should bring about profound changes in society and social relationships. Fortunately, historical events had not destroyed the internal logic of the arts, though it had been strongly affected by them, and although artistic research was again brought to an abrupt halt by the Second World War it was not forgotten by the generation which came to the fore in the 1950s.

To fully understand the aesthetic scope of Dada, De Stijl, the Bauhaus and Constructivism – movements which were linked one to another by exhibitions, periodicals and personal contacts – we must not therefore regard them as simply undertaking theoretical pictorial or sculptural research into colour, line and form, but as pursuing a social and political project. The Dada movement in Zurich and Berlin and the Russian avant-garde of the Bolshevik period brought politics back into 20th-century art with a

∧
Georges Vantongerloo
Antwerp, 1886 – Paris, 1965
S x R/3
1933–34

Iron
100 x 100 x 100 cm
Gift of Max Bill, 1980
AM 1980-353

vengeance, and it is fair to describe the artists concerned as socially and politically committed. Merely by deciding to use new materials, refusing to abide by the rules of representational art and preferring abstraction, they were taking up a position vis-à-vis the established order, challenging the way in which works of art were produced and accepted. The outlook of these artists could be described as Utopian because they believed that, by bringing about a radical formal transformation – and here we must include design and architecture – society would also be transformed, leading to a radiant future, or at least a future that was more open and promising.

Although it was not the aim of Dada in either spirit or letter to set up yet another movement or programme, the attempt to rally the various trends or artists of the avant-garde contradicts the charge of nihilism levelled against the Zurich group, though it is

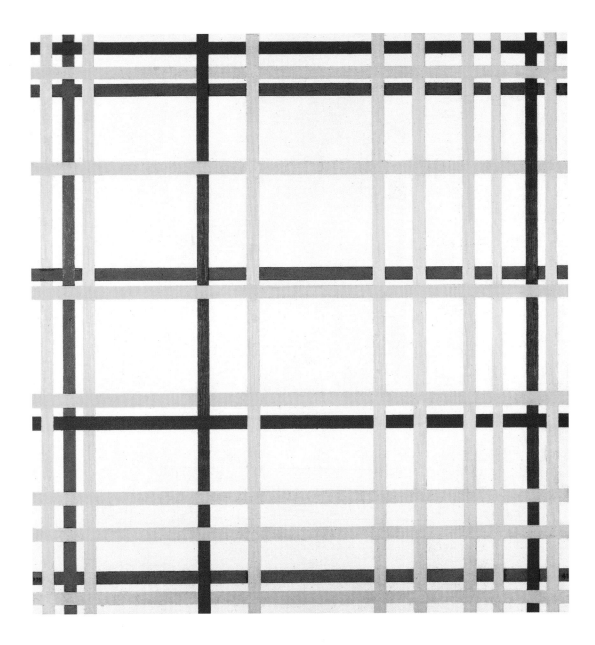

∧
Piet Mondrian
Amersfoort, 1872 –
New York, 1944
New York City
1942

Oil on canvas
119.3 x 114.2 cm
*Purchased with a special loan
and help from the Scaler
Foundation, 1984*
AM 1984-352

true that Dada was long mistrustful of human nature. More voluntarist in outlook – though it was also a question of personalities – the members of the De Stijl, Bauhaus and Constructivist movements were inclined to generalise, if not to universalise, the aesthetic challenge they had taken up. The very name De Stijl implied an entire programme: 'style' was to be applied to painting and sculpture, to be implemented in design as in architecture. Defined mainly by Theo van Doesburg and Piet Mondrian, the programme was to work with simple lines (vertical and horizontal), primary colours (yellow, red, blue) and elementary shapes, surfaces and volumes that could be easily perceived and understood by anyone. Typical examples of this basic style are van Doesburg's *Pure Painting*, Georges Vantongerloo's sculpture *S x R/3*, and one of Mondrian's last paintings, *New York City I*.

>
Paul Klee
Münchenbuchsee, 1879 – Locarno, 1940
Pfeil im Garten (Arrow in the Garden)
1929

Oil and tempera on linen
70 x 50.2 cm
Gift of Louise and Michel Leiris, 1984
AM 1984-557

>
Paul Klee
Münchenbuchsee, 1879 – Locarno, 1940
Rhythmisches (Rhythmus)
1930

Oil on canvas
69.6 x 50.5 cm
Purchased 1984
AM 1984-356

v
Wassily Kandinsky
Moscow, 1866 – Neuilly-sur-Seine, 1944
Gelb-Rot-Blau (Yellow-Red-Blue)
1925

Oil on canvas
128 x 201.5 cm
Gift of Nina Kandinsky, 1976
AM 1976-856

This plastic grammar that could be extended to any artistic production was given the name 'Neo-Plasticism' and its most fervent defender was Mondrian, whose many writings on the subject advocated formal principles dependant on precise content, as it was always necessary to lend form to the experience of reality. In his view, paintings, and art in general, should be conceived on the basis of plastic laws and – over and above geometrical forms – in accordance with a constant equilibrium obtained thanks to oppositional relationships between lines, surfaces and colours, the simultaneous maintenance of continuity and discontinuity, calm and tension, parts and the whole, and a refusal of symmetry. But these plastic laws had psychological and social consequences as, in Mondrian's view, they brought to light the true structure of the world which is hidden from us beneath appearances: 'Balance, by the equivalence of nature and spirit, the individual and the universal, feminine and masculine, the general principal of Neo-Plasticism, is

achievable not only in the realm of art but also in man and society. Where society is concerned, the equivalence of the material and the spiritual can create a harmony hitherto unknown. Neo-Plasticism demonstrates the right order. It demonstrates equity, because the equivalence of plastic means in the composition indicates, for everyone, rights which are of equal value but nevertheless different. Balance through contrary and neutralising opposition annihilates individuals as distinct personalities and so creates the future society as a true unity.'

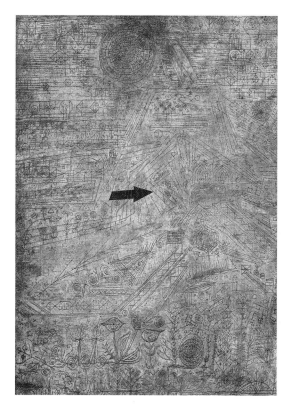

When, in 1922, Kandinsky became a teacher at the Bauhaus, then situated in Weimar, he entered on a new phase of his career as a painter, geometrising and clarifying the shapes and colours which he had previously worked on more spontaneously and gesturally. But he soon began to mix geometrical elements and free forms, as is evident in *Gelb-Rot-Blau* (*Yellow-Red-Blue*, 1925), a work typical of this period. Also on the staff of the Bauhaus (from 1921) was Paul Klee. During his years as a teacher, Klee had developed a complex system which he incorporated into his paintings and in his more general aesthetic reflections on painting itself. His system of graphic signs with symbolic connotations was based on such elements as lines, arrows, directions and the search for balance and harmony (*Pfeil im Garten / Arrow in the Garden*; *Rhythmisches / Rhythmus*). Not inclined to see painting as potentially leading to a spiritual world beyond the material, László Moholy-Nagy, who also taught at the Bauhaus from 1923 to 1928, was then producing abstract canvases (*Composition A.XX*) in a style akin to that of the De Stijl group and the Constructivists. Using transparent colours, the artist sought to fulfil his longstanding aim to 'paint with light'. Photographer, stage designer, typographer, film-maker and designer, like many artists of the period, Moholy-Nagy played an active part in the social and political movements of the time, directly through his films and in his choice of deliberately modern, avant-garde materials, such as casein plastics, Plexiglas, Bakelite and aluminium, which he used experimentally as a support for paintings and for some of his sculptures.

∧

Katarzyna Kobro
Moscow, 1898 – Łódź, 1951
Sculpture spatiale
(Spatial Sculpture)
1928

Painted steel sheeting
44.8 x 44.8 x 46.7 cm
Purchased 1985
AM 1985-18

∧

El Lissitzky
Polchinok, 1890 –
Schodnia, 1941
Study for *Proun RVN 2*
1923

Pencil and gouache on paper
20 x 20 cm
Purchased 1978
AM 1978-28

For an artist, being of one's time therefore meant working with modern materials and forms. This was also an article of belief of the Russian Constructivists, for whom the raw material conditioned a good part, if not all, of the work. Directly influenced by Constructivism (she lived in Russia from 1917 to 1924), in her *Spatial Sculpture* the Polish artist Katarzyna Kobro adopted not only the movement's plastic principles but also its aesthetics. This work is based on a mathematical principle of modular construction using the progression of numbers associated with the medieval mathematician Leonardo Fibonacci (1, 1, 2, 3, 5, 8, 13, etc., obtained by adding the last number to the one before it). Like Moholy-Nagy, El Lissitzky was fascinated by the idea of the artist as engineer and was himself an accomplished architect, designer, photographer and typographer. During the 1920s he developed a series of *Prouns* (the abbreviation of the Russian 'for the affirmation of innovation in art'), such as the study for *Proun RVN 2*, in which he sought to renew the concept of perspective, the nature of the support, and the perception of painting. For Lissitzky, renewing this concept also meant reconsidering one's vision of society, man and what he produces. But it is undoubtedly in Vladimir Tatlin's *Model for a Monument to the Third International* that the Utopian fusion of art and socio-political concerns is most evident. This monument, which was never built, was intended to house the offices of the Komintern. It was to have been a metal and glass construction, four hundred metres in height, consisting of three geometrical structures. Each was designed to turn on itself at a different speed: the cube at the base once a year, the pyramid above it once a month, and the cylinder at the top once a day.

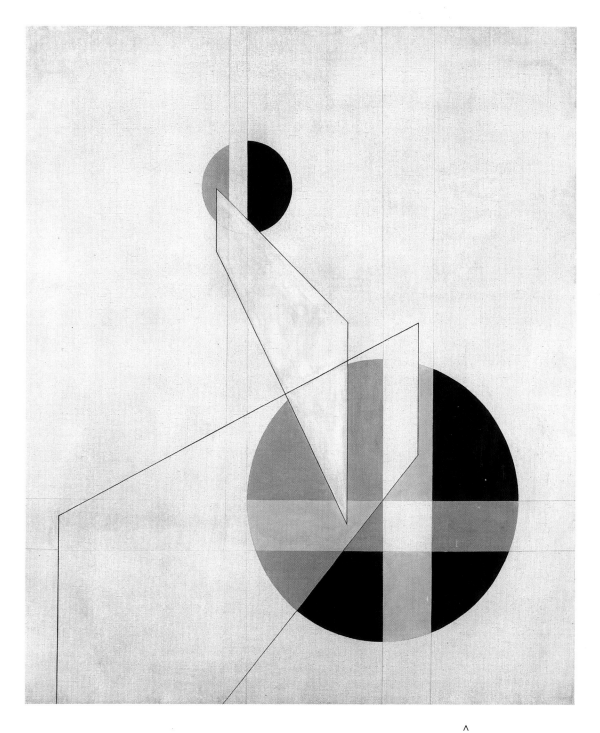

∧
László Moholy-Nagy
Borsod (Hungary), 1895 –
Chicago, 1946
Composition A.XX
1924

Oil on canvas
135.5 x 115 cm
*Gift of the Friends of the Musée
National d'Art Moderne, 1962
AM 4025 P*

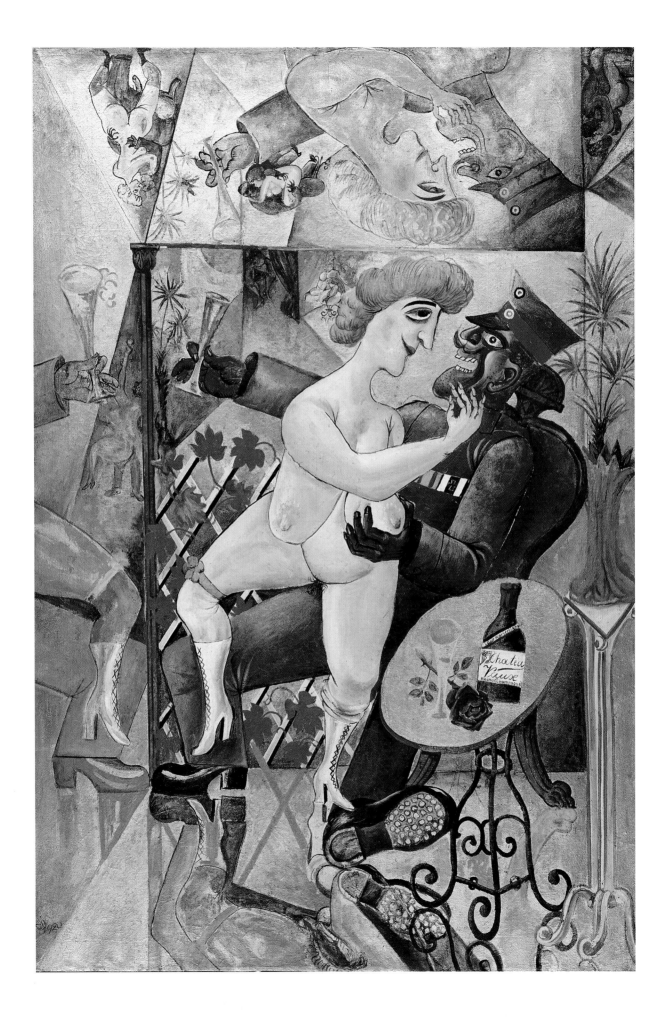

Reality and Surreality
1919–1947: from different types of realism to the beginnings of Abstract Expressionism

Given the catastrophic state of Europe in the post-war period, the opposition between the movements discussed earlier was not only formal but also ideological, the war having exacerbated – or perhaps we could say accelerated – the relationship between content and form.

Despite their different aesthetic and moral standpoints, the works of the 1920s nevertheless exhibit the common characteristic of being poised between revolt and despair. Lives and dreams had been broken and this resulted in disturbing images of man, bitter criticisms, and an irony and detachment equal to the agony that had provoked them. If we are to understand artistic developments from the end of hostilities to the election of Hitler in 1933, we must continually bear in mind the impact of the Great War on artists' projects, which underwent a profound change of emphasis. Brecht said of the disaster that it had been 'a great practical lesson in the perception of a new vision of things'. This new vision of things and, more generally, this new conception of the world, tended to oscillate between two poles, some elements of which derived from the artistic discoveries of the pre-war period: further progress on the route opened up by abstraction, and a continuation of figurative painting and its themes. Although figurative painting had been overshadowed by the triumph of non-figurative art in the second decade of the century, it nevertheless continued to exist throughout Europe and, after 1919, the figuration that prevailed was one reconsidered in the light of the terrible events of the

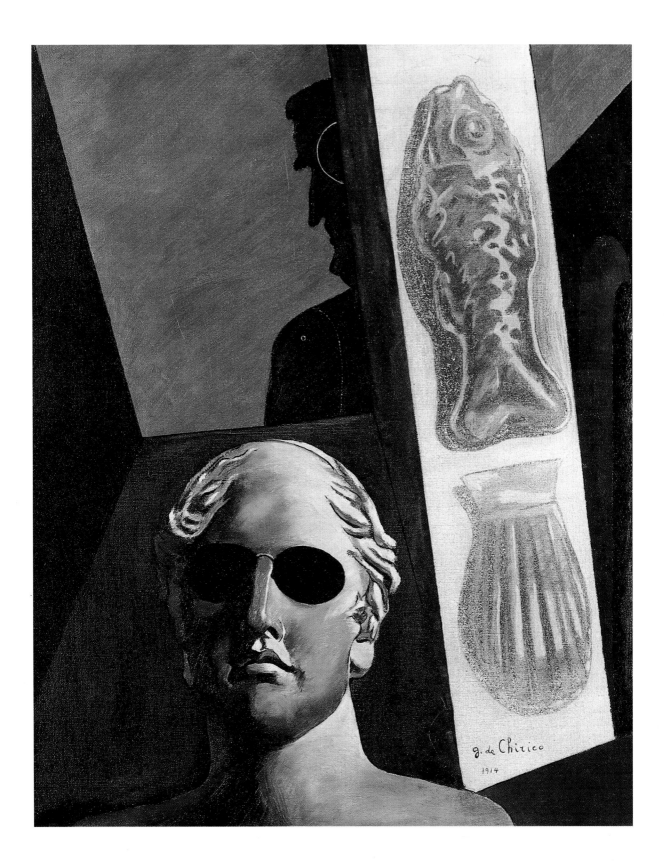

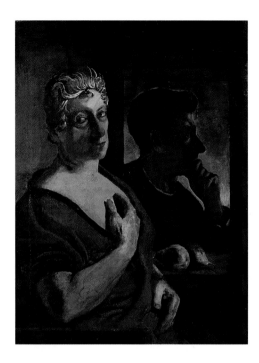

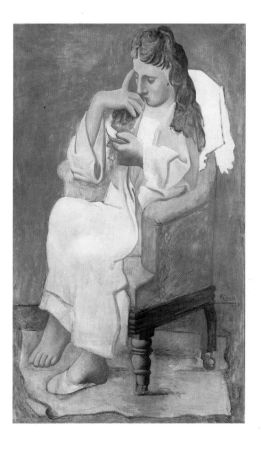

<<
Giorgio de Chirico
Volos (Greece), 1888 – Rome, 1978
Portrait prémonitoire de
Guillaume Apollinaire
(Premonitory Portrait of
Guillaume Apollinaire)
1914

Oil on canvas
81.5 x 65 cm
Purchased 1975
AM 1975-52

<
Giorgio de Chirico
Volos (Greece), 1888 – Rome, 1978
Ritratto dell'artista con la madre
(Portrait of the Artist with his
Mother)
1919

Oil on canvas
79.7 x 60.4 cm
Purchased 1992
AM 1992-58

<
Pablo Picasso
Malaga, 1881 – Mougins, 1971
La Liseuse
(Woman Reading)
1920

Oil on canvas
166 x 102 cm
Collection of Baron Kojiro Matsukata,
transferred to the Musée National
d'Art Moderne under the terms of
the peace treaty with Japan, 1959
AM 3613 P

time. What was generally termed the 'return to order' should rather be referred to as the 'realist movements', to cover both the return to classical painting and many of the avant-garde formal characteristics of the pre-war period, which had not disappeared. Giorgio de Chirico, for instance, was one of the first to return to a form of classicism after his 'metaphysical painting' of the war years, creating works which also had considerable influence on the Surrealists (*Portrait prémonitoire de G. Apollinaire / Premonitory Portrait of G. Apollinaire*; *Ritratto dell'artista con la madre / Portrait of the Artist with his Mother*). Also regarded as one of the artists responsible for a return to the grand tradition in painting, Picasso nevertheless continued to produce canvases mixing the formal discoveries of his Cubist period with neoclassical elements (*La Liseuse / Woman Reading*).

It was above all in Germany that the streams contributing to a profound redefinition of the human image flowed together, beginning with the artists of the first wave of Expressionism, Die Brücke. On the whole, the works they produced individually during the 1920s retained traces of the years they had spent working as a group, though in a less violent mode. The angular lines, garish colours and impasto effects had softened somewhat, and their painting consequently lost much of its force. At the same time, so-called 'independent Expressionist' artists of the same generation, such as Max Beckmann, Otto Dix and Georg Grosz, produced much stronger, more violent and shocking works, taking as their subject matter urban scenes, contemporary social events and the war. In both theme and treatment, there is no doubt that their brothel scenes, rapes, self-portraits, portraits of friends, tortures, murders, crimes of passion and soldiers in the trenches belong not only to Expressionism but also to what was variously described as 'critical realism', 'Naturalism', 'verismo' or Neue Sachlichkeit (New Objectivity).

Whatever their particular brand of realism, all these artists sought, albeit with very different materials, to bear witness to the same human experience: the rage of despair that made them hate war and its catastrophes and led them to denounce man's inhumanity to man in contemporary society. In 1925, Grosz wrote: 'The exponent of verismo holds up a mirror to his contemporary to let him see his ugly mug. I drew and painted from a spirit of contradiction, and through my work I tried to convince the world that it is ugly, sick and deceitful.' The term Neue Sachlichkeit (New Objectivity) – coined by the director of the Mannheim Kunsthalle, Gustav Hartlaub, who organized the first exhibition devoted to the movement in 1925 – evinced a desire to render the truth of the real world in its toughest and most ordinary aspects, distorting them as little as possible and casting an *objective* eye on people, things and events. This explains why a Neue Sachlichkeit painter like Schad (*Graf Saint-Genois d'Anneaucourt / Count Saint-Genois d'Anneaucourt*) developed the practice of photography, the better to capture the phenomena of the real world. The quest for bare,

>
Christian Schad
Miesbach, 1894 –
Stuttgart, 1982
*Graf Saint-Genois
d'Anneaucourt
(Count Saint-Genois
d'Anneaucourt)*
1927

Oil on wood
86 x 63 cm
Purchased 1999
EC-1999-3-AP

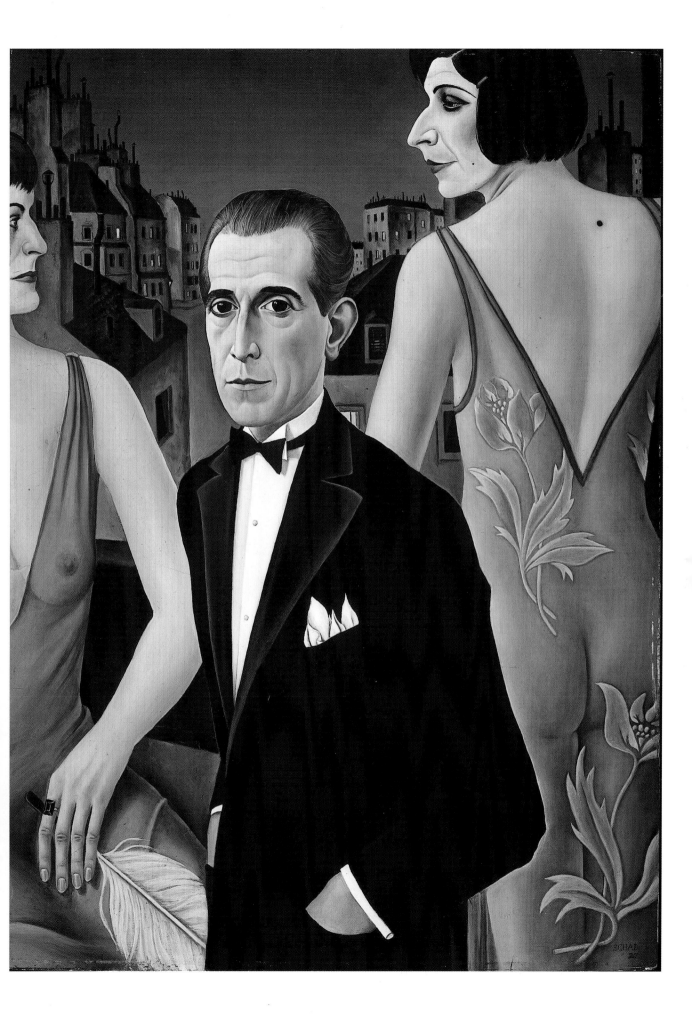

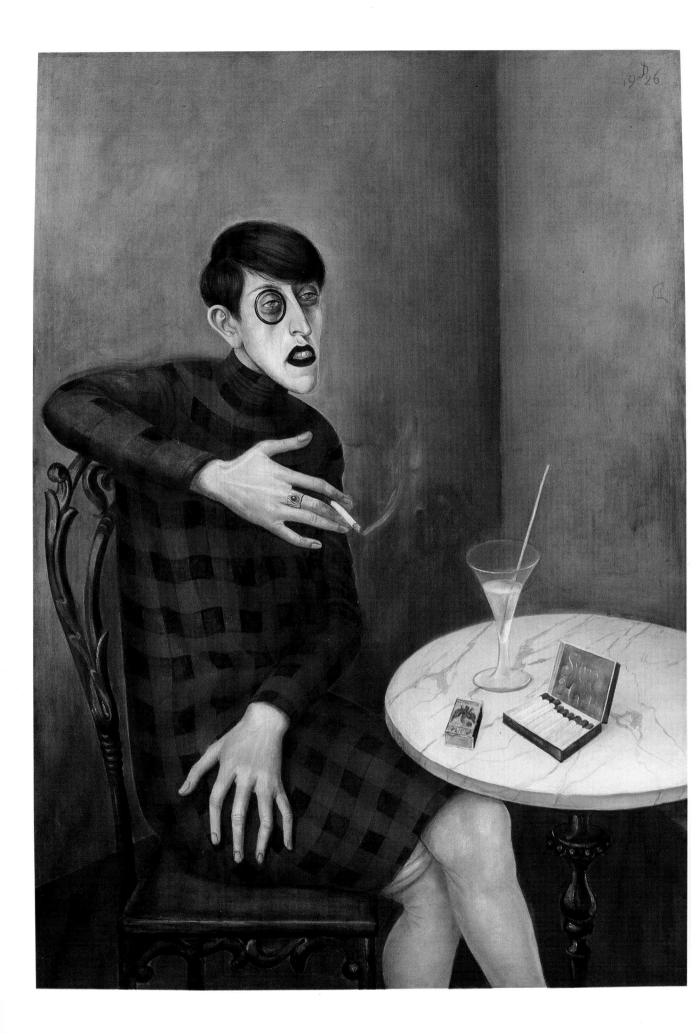

unadorned truth is also evident in the work of Otto Dix, who painted cruel pictures of middle-class life (*Erinnerung an die Spiegelsäle von Brüssel / Souvenir of the Galerie des Glaces, Brussels*) and the intellectual élite (*The Journalist Sylvia von Harden*), emphasising the raw facts and pettiness of human existence.

At around the same time, other thinkers were seeking release from the oppression of reality in what they termed 'surrealism' (Apollinaire in the preface to his play *Les Mamelles de Tirésias*, 1917) or 'surreality' (the writer Y. Goll in 1918, referring to Mallarmé) – terms which did not go unnoticed by André Breton, even if the activities of the movement he promoted some years later were rather different. For the thing which completely transformed the 'surrealist' aesthetic into full-blown 'Surrealism' was the modern discovery of the unconscious. To claim that many 20th-century works of art would not have taken the direction they did but for Freud's discoveries of the unconscious and his methods of accessing it is no mere retrospective speculation. And though Surrealism was one of the first movements in art to draw consistently on Freud's discoveries, the first links between the thought of the father of psychoanalysis and some of the future leaders of Surrealism were established before the movement was launched (i.e. before the publication of Breton's *Surrealist Manifesto* in 1924). The process began, as we have already seen, with Max Ernst, and then with André Breton. The latter became indirectly familiar with Freud's ideas (he could not read German) in 1916 when he was working in the psychiatric department of a hospital, and he later used them in his first manifesto. Adopting the format of a dictionary entry, Breton wrote: 'Surrealism, noun. Psychic automatism by which it is intended to express, verbally, in writing, or in any other way, the true functioning of the mind. Thought dictated in the absence of any rational control, and outside of any aesthetic or moral preoccupations. / Philos. Encycl. Surrealism is based on a belief in the superior reality of certain forms of association hitherto neglected, in the omnipotence of dreams, and in the disinterested working of the mind. It tends to ruin permanently all other psychic mechanisms and substitute itself for them in solving the principal problems of life.' As formulated by Freud, the theory of the unconscious

<
Otto Dix
Gera-Untermhaus, 1891 –
Singen, 1969
*La Journaliste Sylvia
von Harden
(The Journalist Sylvia
von Harden)*
1926

Oil and tempera on wood
121 x 89 cm
Purchased 1961
AM 3899 P

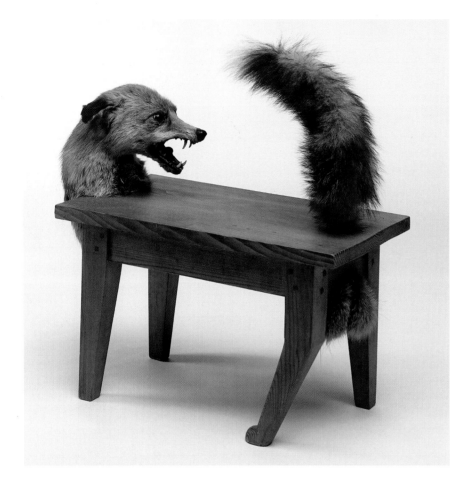

<
Victor Brauner
Pietra-Naemtz (Romania),
1903 – Paris, 1966
*Loup-table
(Wolf-Table)*
1939-47

Wood and parts of a stuffed fox
54 x 57 x 28.5 cm
*Gift of Jacqueline
Victor-Brauner, 1974
AM 1974-27*

∨
Alberto Giacometti
Stampa (Switzerland) 1901 –
Coire (Switzerland), 1901
*Boule suspendue
(Suspended Ball)*
1930-31

Wood, iron and rope
60.4 x 36.5 x 34 cm
*Purchased 1996
AM 1996-2058*

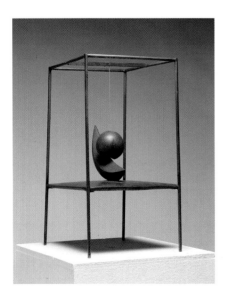

opened up a deep wound in human reason by explaining that all actions and thoughts were merely the result of urges and deeply buried fantasies. The ultimate reality of man was the unconscious. So the Surrealists sought to bring to light through literature, painting, collage, film, and found or subverted objects (*Loup-table / Wolf-Table* by Victor Brauner) the true psychic life of the human being. The encounter with the ideas of Freud was undoubtedly most evident in the work of Catalan artist Salvador Dalí, who worked to develop a method of painting founded on a delirious interpretation of reality, which he referred to as 'critical paranoia'. Using this technique, he painted his famous 'double images', in which a head can also be a fruit dish, a group of sitting people a face, or a woman's body a horse (*Invisible Lion, Horse, Sleeping Woman*). In the first issue of the periodical *Le Surréalisme au service de la révolution* (July 1930), Dalí

published 'L'Âne pourri' (the rotting donkey), a text in which he explained his method, which incidentally influenced a young psychoanalyst who drew on it for his doctoral thesis, published in 1932: Jacques Lacan. As the unconscious had become, one might say, the new raw material of the artist, the Surrealist aesthetic came to be built on processes modelled on the association of ideas, dreams, hypnosis and chance, as well as the personal obsessions of the individual. This led to the production of 'objects with a symbolic function' which transposed sexual fantasies (Giacometti, *Boule suspendue* / *Suspended Ball*), or images which seemed to come directly from the dreams of their creators (Max Ernst, *Chimera*). But it needs to be understood that Surrealist sculptures and paintings did not represent a flight from the reality of this world but, on the contrary, a return to the ultimate reality, that of the unconscious, from which all desire and all existence stem.

The Surrealists therefore sought to express the unconscious directly using all sorts of procedures to bypass reason, as in the automatic drawings of André Masson (1925). Masson, who had drawn inspiration from the 'automatic writing' first practised by Breton and Soupault in 1919 in their joint text *Les Champs magnétiques* (Magnetic Fields), tried to render the movements of mental fantasy in ink drawings in which his hand travelled rapidly over the paper serving as an oscillograph of the unconscious. *Les Chevaux morts* (*The Dead Horses*) is an equivalent in the medium of paint. Automatic techniques obviously emphasised the gestural: Masson in his drawings was no longer depicting a figurative or abstract world on paper but actively presenting gesture. The way the drawing was projected onto the surface became the subject of the work, and two other important factors – subsequently taken up by other artists in the 1940s – were brought into play: spontaneity and speed of execution.

Due to force of events, purely formal research into gesturality did not develop in Europe but in the United States, as a result of the influx of a number of Surrealist painters, in particular Roberto Matta in 1939 and André Masson in 1941. For despite some isolated experiments (in particular by the American painter Mark Tobey), it was undoubtedly the Surrealists who triggered the decisive

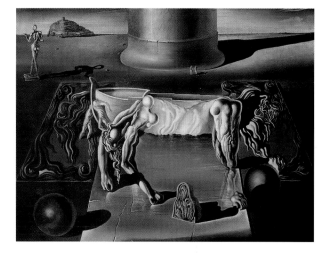

∧
Salvador Dalí
Figueras (Catalonia), 1904 – 1989
Lion, cheval, dormeuse invisibles
(Invisible Lion, Horse,
Sleeping Woman)
1930

Oil on canvas
50. 2 x 65. 2 cm
Gift of the Association Bourdon, 1993
AM 1993-26

∨
Max Ernst
Brühl, 1891 – Paris, 1976
Chimère
(Chimera)
1928

Oil on canvas
114 x 145.8 cm
Purchased 1983
AM 1983-47

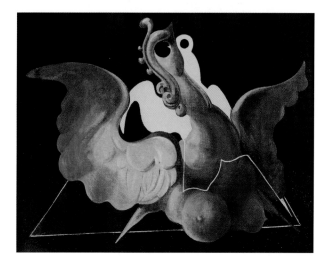

∧
Roberto Matta
Santiago (Chile), 1911
Xpace and The Ego
1945

Oil on canvas
202.2 x 457.2 cm
Purchased 1983
AM 1983-94

<
Arshile Gorky
Tiflis (Armenia), 1904 –
Sherman (Texas), 1948
Landscape-Table
1945

Oil on canvas
92 x 121 cm
Purchased 1971
AM 1971-151

<
André Masson
Balagny, 1896 – Paris, 1987
Les Chevaux morts
(The Dead Horses)
1927

Oil and sand on canvas
46 x 55 cm
Gift of Michel and Hélène
Maurice-Bokanovski, 1983
AM 1983-326

interest in automatic drawing and gestural expression. Rothko claimed to have made some automatic drawings in 1938, a year before the arrival in New York of Matta, who then introduced artists such as Motherwell, Pollock and Gorky to automatic writing. One of Gorky's paintings, *Landscape-Table*, is strangely akin to some of Matta's paintings from the late 1930s. Paintings of this kind by Matta, or his *Xpace and the Ego*, which dates from the American period of Surrealism, were to influence many works produced by the American Expressionist painters from the mid-1940s on, particularly as regards line and the movement of the hand over the canvas. In 1939, at a time when many Surrealist events were taking place in New York, Breton wrote a warning article, 'Prestige d'André Masson', in a double issue of the Surrealist periodical *Minotaure*, in which he declared: 'It is high time to react against the idea of the work-of-art-at-so-much-the-yard which, like a roll of tape, can never run out . . . and replace it with the work-of-art-as-event.' The art scene in America was therefore ready for the advent of the country's first truly modern works: Jackson Pollock's drip paintings.

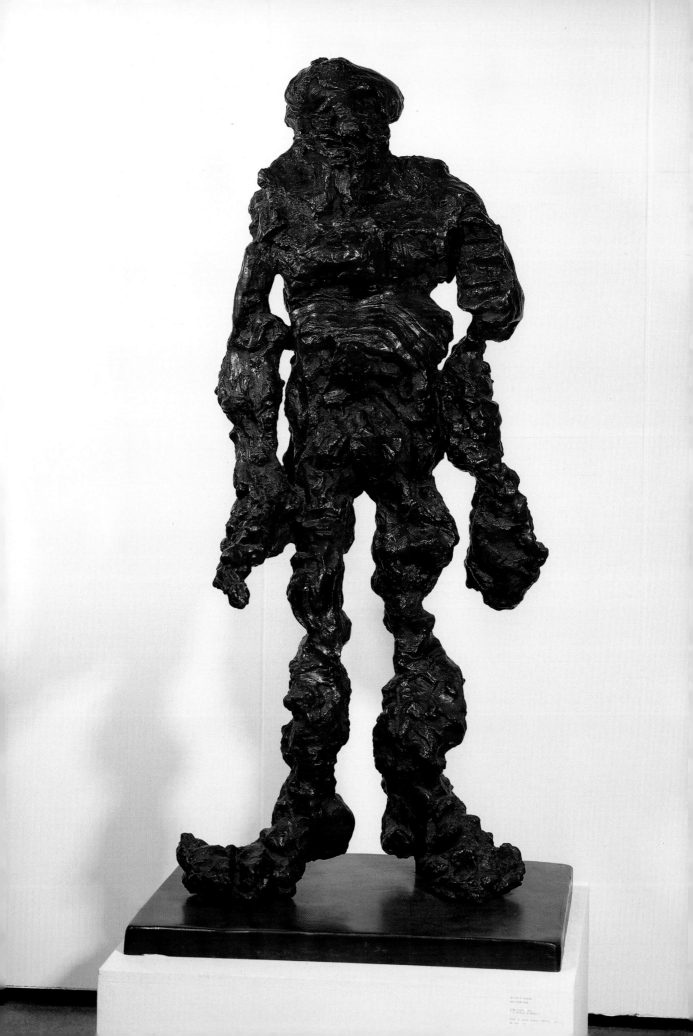

Body, Figure, Gesture
1925–1965: from Brancusi to Abstract Expressionism

The human body underwent many distortions, deformations and disfigurements at the hands of the avant-garde movements, but these were simply plastic conventions, stages in redefining the notion of 'representation'.

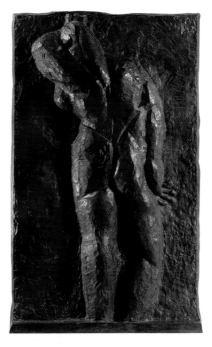

>
Henri Matisse
Le Cateau-Cambrésis, 1869 – Nice, 1954 .
Nu de dos, 2e état
(The Back II)
1913

Bronze
188 x 116 x 14 cm
Purchased by the state, 1964
Attribution 1970
AM 1712 S

<
Willem de Kooning
Rotterdam, 1904 – East Hampton, 1997
The Clam Digger
1972

Bronze
151 x 63 x 54 cm
Purchased 1979
AM 1978-735

For the body to be represented, it must be present in some shape or form in the work of art. It must be possible to recognise its main features, even if they are simplified to an extreme, as in Matisse's *Nu de dos II (The Back II)*, in which he avoids the complexity of a frontal view. This did not of course prevent him from subtly interweaving human and geometrical forms, as in *Figure décorative sur fond ornemental* (*Decorative Figure against Ornamental Background*), in which he plays on the terms and on the perceptual relationship

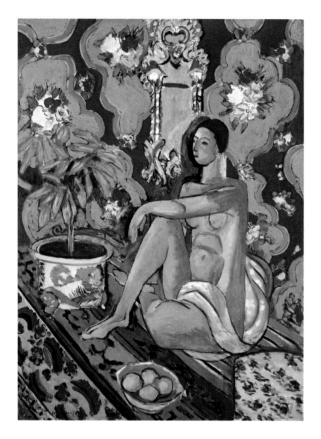

<

Henri Matisse
Le Cateau-Cambrésis, 1869 –
Nice, 1954
*Figure décorative sur fond
ornemental*
*(Decorative Figure against
Ornamental Background)*
1925–26

Oil on canvas
130 x 98 cm
Purchased by the state, 1938
Attribution 1938
AM 2149 P

>

Alberto Giacometti
Stampa (Switzerland), 1901 –
Coire (Switzerland), 1966
Femme debout II
(Standing Woman II)
1959–60

Bronze
275 x 32 x 58 cm
Purchased 1964
Attribution 1970
AM 1707 S

∨

Germaine Richier
Grans (Provence), 1904 –
Montpellier, 1959
L'Orage
(The Storm)
1947–48

Bronze
200 x 80 x 52 cm
Purchased by the state, 1949
Attribution 1949
AM 887 S

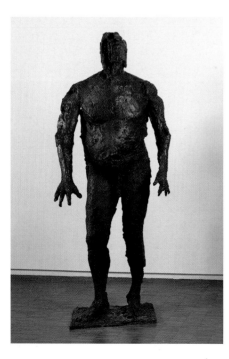

established between figure and background. Sculpture had been essentially abstract since the 1920s and until the late 1940s, with the exception of Matisse, Picasso (*Petite fille sautant à la corde* / *Girl Skipping*), Henry Moore, Germaine Richier (*L'Orage* / *The Storm*) and Giacometti (*Femme debout II* / *Standing Woman II*), there were few major figurative sculptors – or at any rate sculptors who integrated parts or aspects of the human body into their works, as did Lipchitz (*Figure*), Brancusi (*Le Commencement du monde* / *The Beginning of the World*)

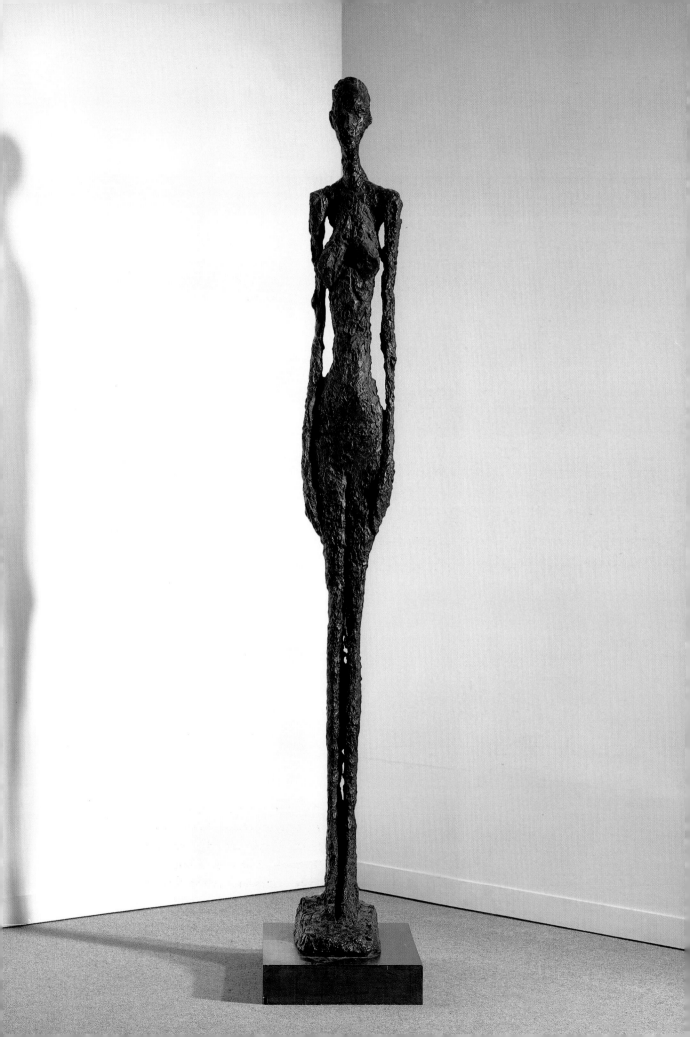

>
Jacques Lipchitz
Druskininkai (Lithuania), 1891 –
Capri, 1973
Figure
1926-30

Painted plaster
220 x 95 x 75 cm
*Gift of the Jacques and Yulla
Lipchitz Foundation, 1976*
AM 1976-822

∨
Constantin Brancusi
Pestisani-Gorj (Romania), 1876 –
Paris, 1957
*Le Commencement du monde
(The Beginning of the World)*
1924

Polished bronze
19 x 28.5 x 17.5 cm
Bequest of Constantin Brancusi, 1957
AM 4002-63

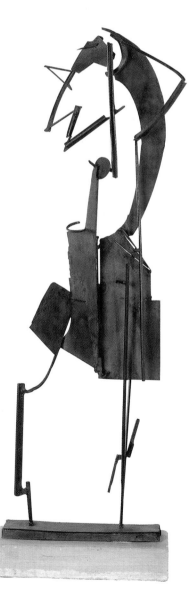

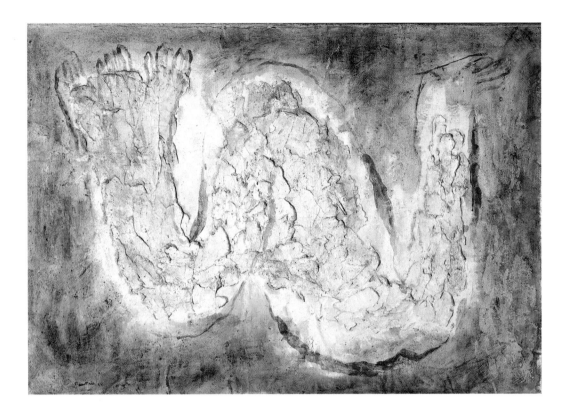

<

Julio González
Barcelona, 1876 – Paris, 1942
Femme se coiffant I
(Woman Doing her Hair)
c. 1931

Welded wrought iron
168.5 x 54 x 27 cm
Gift of Roberta González, 1953
AM 951 S

∧

Jean Fautrier
Paris, 1898 – Chatenay-Malabry, 1964
L'Écorché (Corps d'otage)
Écorché (Body of Hostage)
1944

Oil on pasted paper on canvas
80 x 115 cm
Donated in lieu of inheritance tax 1997
AM 1997-93

∨

Jean Dubuffet
Le Havre, 1901 – Paris, 1985
Le Métafisyx
1950

Oil on canvas
116 x 89.5 cm
Purchased 1976
AM 1976-12

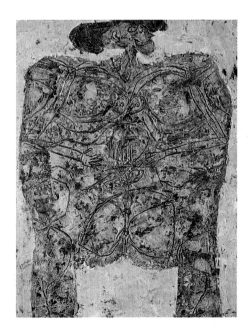

or González (*Femme se coiffant / Woman Doing her Hair*). The image of the human body was in some cases so manipulated by the artist, as in de Kooning's *Clam Digger*, as to be on the boundary between incorporation and decomposition, traditional representation and abstraction of form. We also encounter this problem of semi-abstract figurability in the paintings of Fautrier (*L'Écorché*) and those of Dubuffet's 'matiériste' period (*Le Métafisyx*). The human figure was also

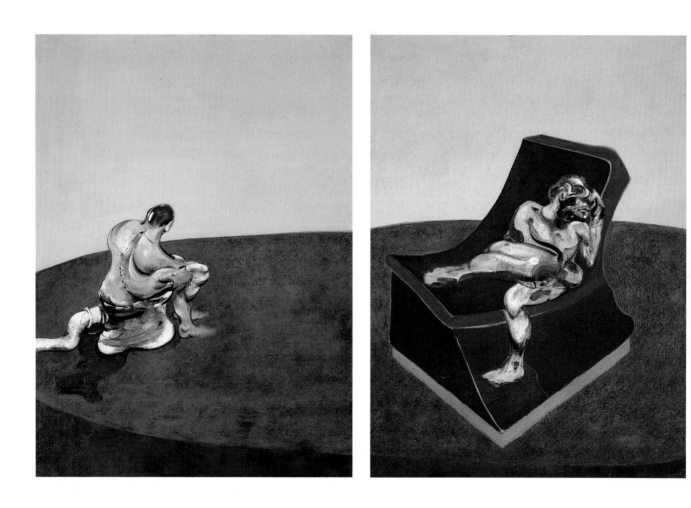

powerfully called into question in the works of Francis Bacon (*Three Figures in a Room*), which combine elements of the human, the animal and the inanimate. An even larger question overshadows this proliferation of works. Rather than an issue of form, the real question – whether they are abstract or figurative, or a mixture of the two – is the more open and ambivalent one of the figure and figuration.

∧
Francis Bacon
Dublin, 1910 – Madrid, 1992
Three Figures in a Room
1964

Oil on canvas
198 x 441 cm
Purchased 1968
Attribution 1976
AM 1976-925

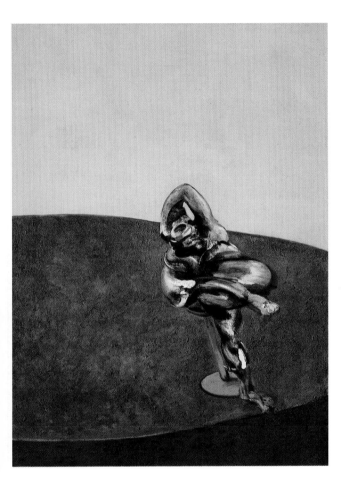

Whereas abstract painting had never entirely divested itself of figuration, abstract sculpture had clearly challenged one of humanity's oldest activities – carving the human figure in stone or wood – which suddenly seemed to be heading for extinction. For it was not only the image of the body and the visual aspect of it that were disappearing, but also its *form*, or in other words a concrete presence which, in art, is the nearest thing to the live human body. No doubt the issues then facing abstract sculpture were much wider-ranging – think, for instance, of ready-mades, the problem of materials and the new techniques to which they were giving rise, and formal issues such as movement (Calder, *Mobile on Two Planes*) – but the paradox is worth emphasising despite the internal logic of art. This leads to another question: does representation imply figuration? Also, the notion of the presence of the body in a work of art had to be reconsidered in terms of the formal discoveries of abstraction. Whereas figuration, as a genre, had in the past implied the presence of the body, and not merely the concreteness of the processes of its representation, abstract art threatened the presence of the body – far more than had been the case with the Fauves or Cubists – because it eliminated the image or form of it from the canvas or sculpture. But if we do not confine ourselves to figuration or the representation of the body in discussing its presence in a work of art, and if we consider in wider terms the idea of projecting the body onto a surface or into a volume, we may then question whether the body had really *disappeared* from 'non-figurative' art. Formats, textures, distances, materials – all these tactile sensations, as opposed to purely optical ones – depend on the bodies of the producer and viewer of the work.

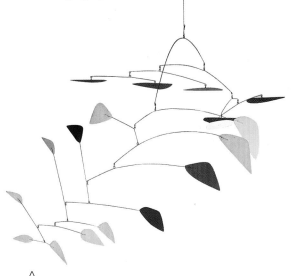

∧
Alexander Calder
Philadelphia, 1898 – New York, 1976
Mobile on Two Planes
c. 1955

Suspended mobile
Painted aluminium sheeting and steel wires
200 x 120 x 110 cm
Gift of the artist, 1966
AM 1514 S

>
Jackson Pollock
Cody (Wyoming), 1912 –
Long Island, 1956
Number 26 A – Black and White
1948

Paint dripped onto canvas
205 x 121.7 cm
Donated in lieu of inheritance tax 1984
AM 1984-312

∨
Hans Hartung
Leipzig, 1904 – Antibes, 1989
T. 1935-1
1935

Oil on canvas
142 x 186 cm
Purchased 1977
AM 1977-2

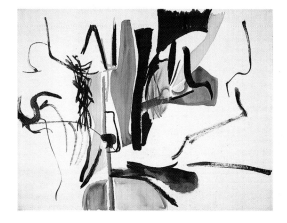

The conjunction of a concrete space and a non-figurative space also gave greater freedom to hand and arm, freeing gesture from the illusory space implied by figuration. Gesture could then exist in its own right. Going beyond the paintings of Masson, gesture is even more clearly evident in the abstract works first produced by Hans Hartung in 1927 using India ink, and in his oil paintings from the 1930s (*T. 1935 – I*) up to the beginning of the Second World War. There is no denying that Hartung contributed to the liberation of gesture and the rapid application of the pictorial material, half symbol half splash of colour. And the work that emerges is the immanent result of such gesture. A gesture cannot be represented, nor imitated. A gesture is just performed, and what we then perceive on the support is simply its actualisation, the transition to action, the action itself.

Following the Surrealist experiments taken up and developed by the Americans, the challenge was increasingly to free the body – of both producer and viewer – in its relationship with the support. And it was through abstraction that artists sought to achieve a new relationship with the body, by integrating it into the space of the work of art. This meant that an image of the body was no longer necessary in the sense that the body present in front of the work was part of its space. The canvas was no longer an object of contemplation, but gradually became a physical space drawing in the whole body of the viewer, not just his sense of sight. In this respect, Pollock's drip paintings, begun in 1947, were exemplary of what the critic Harold Rosenberg first referred to in 1952 as 'Action Painting', in which the act of painting was seen as more important than the result.

Several of Pollock's interpreters have insisted that his drip-painting methods were not adopted to create an image, however abstract, but that drip painting had no legitimacy except as pure gesture. The essential thing was not the final work but the action or event. Nevertheless there is a perfect coincidence between the procedures and the tangle of signs on the canvas. With this network of lines (*Number 26 A*), Pollock undoubtedly dealt a fatal blow to painting as an art of representation, because what we actually see does not imitate, copy or represent, and has no reality except

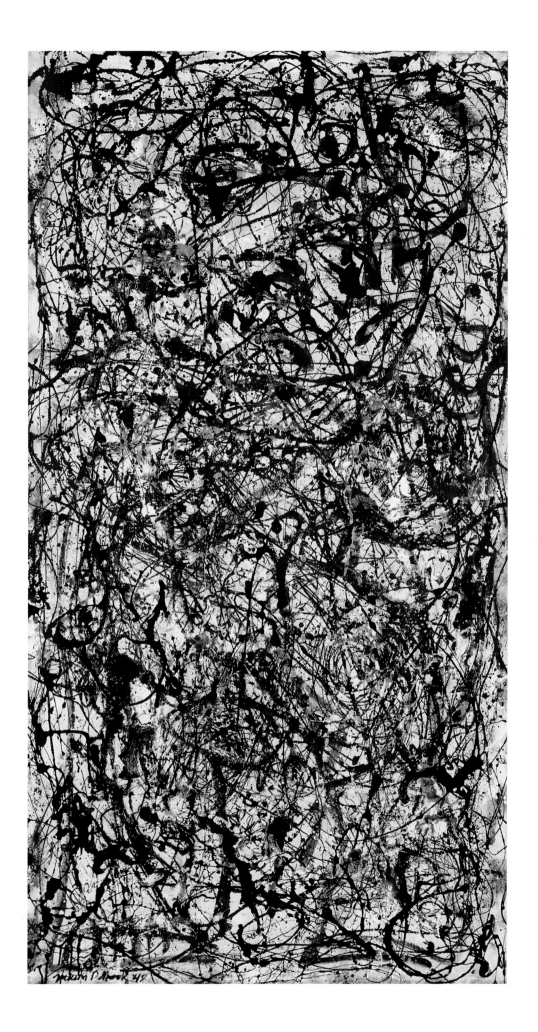

that of the process employed to produce it. What we see is therefore not the image of the process, but the traces – now fixed and frozen – of the process. Applied and interwoven layer by layer, these apparently chaotic features are simply the bodily deployments, movements, positions and postures adopted by Pollock around, in and on the canvas. The spontaneous products of a body in movement, his drip paintings are, from this point of view, strictly *figurative*, not because they are images of a figure but rather the figured traces of a body – and of a body that is alive. When Pollock moved around the canvas, his was not a body turning around another body, but a body within another body, writing all its movements on a virgin surface, in such a way that the canvas had no existence except through the successive and repeated passing of his body over a surface which had literally to be travelled.

In addition to Action Painting, or Abstract Expressionism, which was the most important of the abstract trends which developed in New York in the 1950s and 1960s, two other creative processes emerged: 'Hard Edge' and 'Colour Field Painting'. Despite the differences between these trends, a large number of paintings can be roughly categorised as either 'gestural' or 'geometrical'. These descriptions have not been coined for mere convenience or ease of classification, but because the raw materials – their scale, texture and gestural or geometrical properties – were the result of quite definite and very different aesthetic projects. It is true that the works of Willem de Kooning, Mark Rothko,

>
Barnett Newman
New York, 1905 – 1970
Shining Forth (to George)
1961

Oil on canvas
290 x 442 cm
Gift of the Scaler
Foundation, 1978
AM 1978-371

v
Ellsworth Kelly
Newburgh (New York), 1923
Eleven Panels, Kite II
1952

Oil on canvas
80 x 280 cm
Purchased 1987
AM 1987-560

Barnett Newman and Ellsworth Kelly are abstract (gestural and/or geometrical), but here again we can also point to the retention of a degree of naturalism. This is evident in Kelly's paintings (*Eleven Panels*), often inspired by photographs of the city or of vegetation, in the constant interplay of the figurative and non-figurative (de Kooning), and in an appeal to the sublime and transcendent (Newman). Therefore, although most American abstract painters were concerned with the 'crisis of subject matter', issues of 'what to paint' and 'how to paint' – which might be either complementary or mutually exclusive – the social and moral values attributed to their works could not always be summed up as 'existential' questions, as then understood, i.e. in the Sartrian sense of the word (his works were available in translation in the 1950s). If we consider two artists of the same generation, the question of existence is treated very differently by de Kooning, who was conversant with current Sartrian ideas, and Newman, who believed in a transcendence beyond human understanding.

<

Mark Rothko
Dvinsk, 1903 – New York, 1970
Dark over Brown no. 14
1963

Oil and acrylic on canvas
228.5 x 176 cm
Purchased by the state, 1968
Attribution 1976
AM 1976-1015

<

Antoni Tàpies
Barcelona, 1923
Grand triangle marron
(Large Brown Triangle)
1963

Oil and sand on pasted canvas
195 x 170 cm
Purchased by the state, 1968
Attribution 1980
AM 1980-425

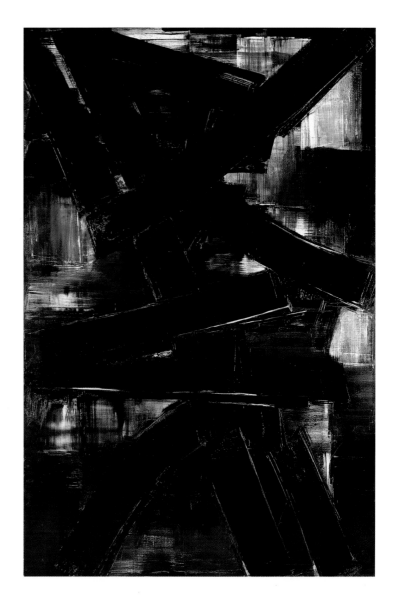

>
Pierre Soulages
Rodez, 1919
Peinture, 195 x 130 cm,
9 octobre 1957
(Painting, 195 x 130 cm,
9 October 1957)
1957

Oil on canvas
195 x 130 cm
Gift of the artist to
the state, 1957
Attribution 1957
AM 3568 P

∨
Georges Mathieu
Boulogne-sur-Mer, 1921
Les Capétiens partout
(Capetians Everywhere)
1954

Oil on canvas
295 x 600 cm
Gift of the Lacarde gallery, 1956
AM 3447 P

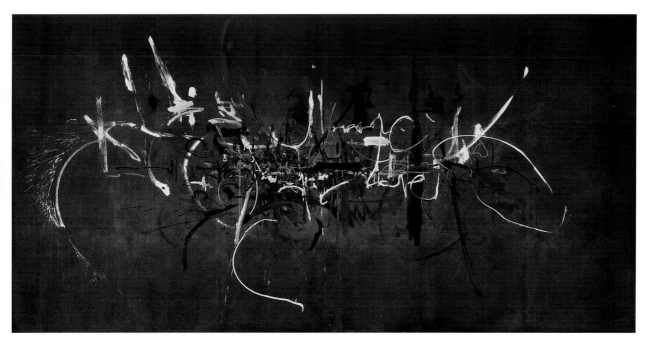

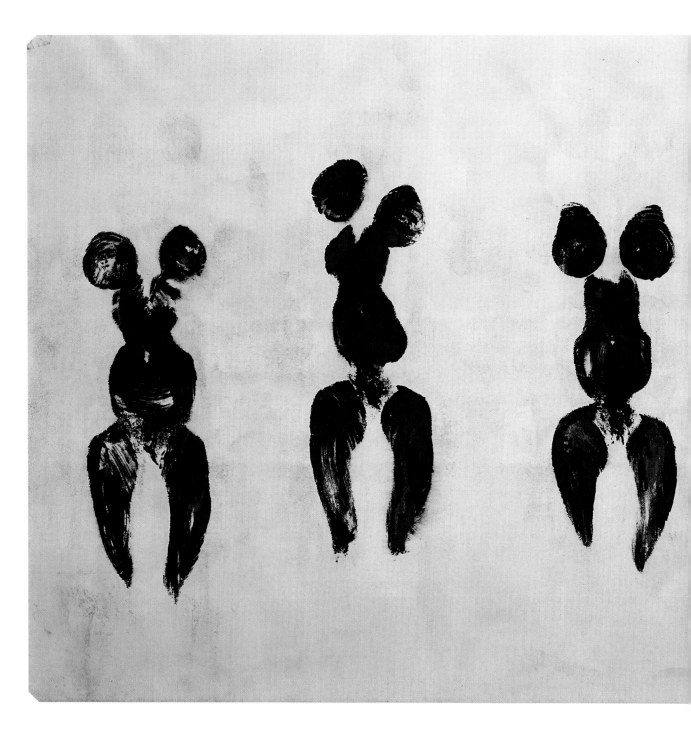

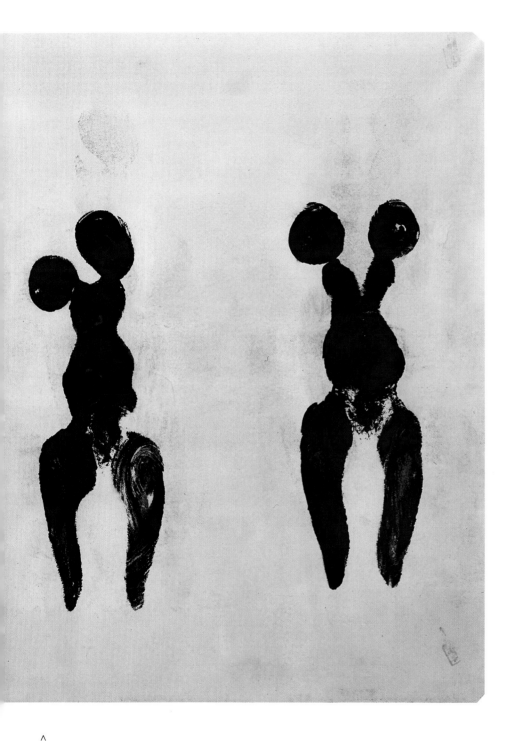

∧
Yves Klein
Nice, 1928 – Paris, 1962
Anthropométrie de l'époque bleue (Ant 82)
(Anthropometry of the Blue Period [Ant 82])
1960

Pure pigment and synthetic
resin on pasted paper on canvas
156.5 x 282.5 cm
Purchased 1984
AM 1984-279

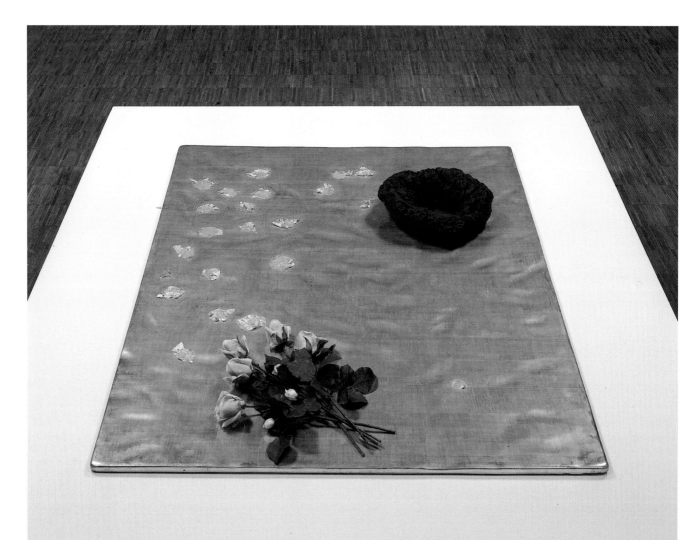

^
Yves Klein
Nice, 1928 – Paris, 1962
Ci-gît l'espace
(Here Lies Space)
1960

Painted sponge, artificial flowers
and gold leaf on panel
125 x 100 x 10 cm
Gift of Mme Rotraut Klein-
Moquay to the state, 1974
Attribution 1975
AM 1975-5

In their very different ways, Pollock (*Number 26 A*), Newman (*Shining Forth*) and Rothko (*Dark Over Brown no. 14*) sought to incorporate the viewer, in particular by using scale and an almost uniform colour field. Though absent as an image, the body is present in this redefinition of the boundaries between perceived object and perceiving subject. Whereas any painting or sculpture involves a greater or lesser projection of the artist's body into a raw material, seeking this projection by means of gesture on canvas reinforces the incorporation of the artist, as can be seen in the work of Georges Mathieu (*Les Capétiens partout / Capetians Everywhere*), Pierre Soulages (*Peinture / Painting*) or

>
Piero Manzoni
Soncino, Cremona, 1933 –
Milan, 1963
Achrome
1959

Kaolin on pleated canvas
140 x 120.5 cm
Purchased 1981
AM 1981-36

v
Lucio Fontana
Rosario de Santa Fe
(Argentina), 1899 –
Varese (Italy) 1968
La Fine di Dio
(The End of God)
1963–64

Oil on canvas
178 x 123 cm
Donated in lieu of
inheritance tax 1997
AM 1997-94

Antoni Tàpies (*Large Brown Triangle*). The term 'incorporation' is perfectly appropriate, to the extent that an artist can integrate, merge or introduce himself into the canvas or sculpture by leaving his mark upon it (Yves Klein, *Anthropométrie* and *Ci-gît l'espace / Here Lies Space*), or without faithfully inscribing upon it the form which was at the origin of this action. For instance, the slashes made by Lucio Fontana in his canvases or the perforations in his *Fine di Dio* (*Death of God*) series result from the physical action of the artist, who seeks not to destroy the canvas but to open it onto a space beyond. Acting in reverse, in accordance with his personal mythology, Piero Manzoni's *Achromes* appear to have absorbed his body and the space around it.

If abstract painting means representing nothing of the visible appearance of reality, not imitating sense data, not giving a mimetic rendering of what exists in the real world, then gestural painting would come into this category. But to the extent that it bears the marks of a body, could not have been made without the presence of this body and is in a sense the imprint of it, does it not in fact include a physical, figural part of the body in question?

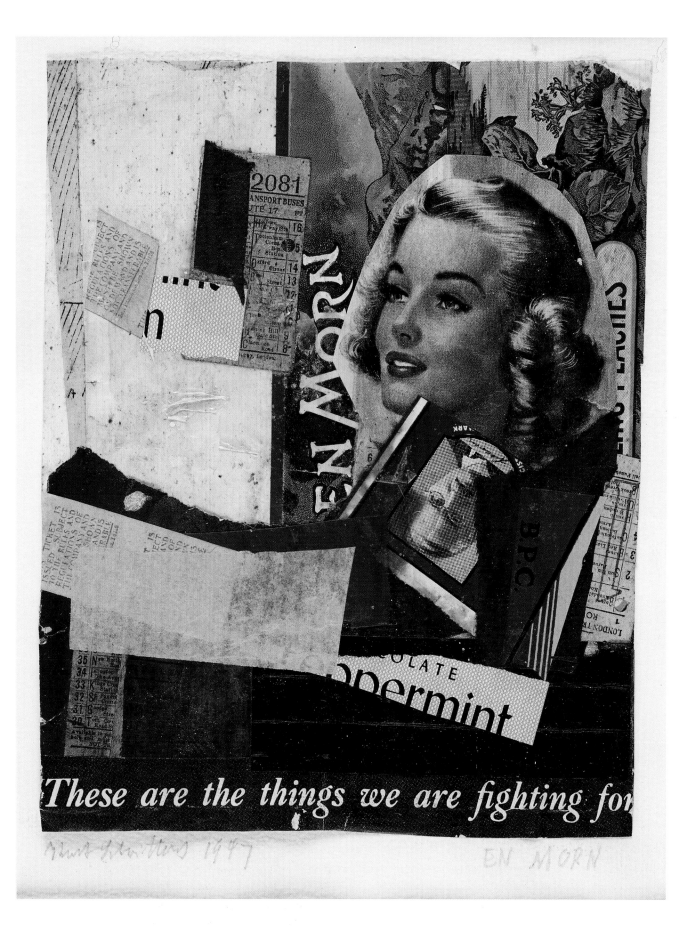

Images and Mass Culture
1947–1975: Pop Art, Nouveau Réalisme, Figuration Narrative

During the period when notions of the figure and figuration were being redefined, there emerged a new approach to reality conveyed by the imagery of consumer culture.

The use of everyday, popular images by Braque and Picasso and the Dadaists and Surrealists, as well as the advertisements created by some of the Russian Constructivists (Rodchenko, Lissitzky), had of course prepared the ground, but the concept of 'mass culture', which was born in the United States at the end of the 1930s and then spread slowly and surely until its full triumph in the 1950s, completely transformed their ideological and artistic status. Because of the terrible necessity of events, but also because of the curious logic of his career, it was Kurt Schwitters, the creator of the one-man Merz movement and an artist spiritually akin to Dada, in exile in England since 1940, who first created collages heralding a new vision of an image-consuming society. Schwitters, in addition to using British magazines, cut pictures from the reviews and illustrated papers he received from a friend in the United States. Works such as *En Morn* (a fragmentary title taken from the label of a Golden Morn can of tinned fruit), which already incorporated popular imagery, influenced the British Pop artists. As early as 1947 (one year before Schwitters's death), one of these artists, Eduardo Paolozzi, created collages which included advertisements – in particular for Coca-Cola – fragments of comic strips and cheap novels, company logos, different styles of typography, and all the imagery that was to become the stock-in-trade of Pop Art.

^
Jacques Monory
Paris, 1934
Meurtre n° 10/2
(Murder no. 10/2)
1968

Acrylic on canvas
and mirror
160 x 400 cm
Gift of the artist, 1975
AM 1975-96

The term Pop (= Popular) Art was first used in the mid-1950s by the British art critic Lawrence Alloway, not with reference to works of art inspired by popular culture but to the products of consumer culture themselves. However, the term was taken up in 1955 by the Institute of Contemporary Art (ICA) in London and subsequently applied to the works of Richard Hamilton, Eduardo Paolozzi, Peter Blake, David Hockney, Peter Phillips, Allen Jones and Ronald B. Kitaj at two epoch-making art shows: 'This is Tomorrow' (1956) and the 'Young Contemporaries Exhibition' (1961). Though it is true that Pop Art was rooted and propagated mainly in Great Britain and the United States, it had notable repercussions on the early works of, among others, Sigmar Polke and Gerhard Richter in 1960s Germany,

and on the Nouveau Réalisme (New Realism) and Figuration Narrative movements in France. This latter tendency, formed in 1965 around the painters Gérard Fromanger, Jacques Monory, Bernard Rancillac and Hervé Télémaque, was strongly marked by television, film and the print media, and was a great deal more politicised in its choice of subjects (Jacques Monory, *Meurtre n° 10/2 / Murder no. 10/2*; Bernard Rancillac, *Suite américaine / American Suite*). Anglo-Saxon and European Pop Art was on the whole characterised by similar backgrounds (capitalist societies), similar subject matter (cultural artefacts, consumer goods, logos, advertising material, designs, stars), as well as recurring techniques and processes (silkscreen, photography, enlargements, and the use and misuse of everyday objects).

^
Bernard Rancillac
Paris, 1931
*Suite américaine
(American Suite)*
1970

Acrylic on canvas
195 x 402 cm
Purchased by the state, 1973
Attribution 1976
AM 1976-1005

>
Jasper Johns
Allendale (South Carolina)
1930
Figure 5
1960

Encaustic paint and newspaper
pasted onto canvas
183 x 137.5 cm
Gift of the Scaler Foundation, 1976
AM 1976-2

It was undoubtedly in the United States that Pop Art found its full expression, but there too it received its initial impetus from the painters of the 1920s, such as Stuart Davis and Gerald Murphy, who had already used advertising material in their cold, precise paintings. But the prime movers were Jasper Johns and Robert Rauschenberg, who in the 1950s began including images of everyday objects in their works (strip cartoons, the national flag, pages from newspapers, throw-away objects, Coca-Cola bottles). Known primarily for his paintings of the American flag, Johns used an encaustic technique to create canvases representing alphabets, figures, targets and maps of the US – elements which were already two-dimensional before being transformed into pictorial images. He also included such everyday objects as chairs, brooms, cups and plates in his compositions. In its size and technique, *Figure 5* is an ironic comment on the gestural emphasis of the Abstract Expressionist painting then in vogue, while at the same time representing a form between abstraction and figuration, between everyday image and formalist image, in which painting for painting's sake (two-dimensionality, colour, composition, process) become the subject of the canvas, and the figure 5 a mere pretext.

Rauschenberg's *Oracle*, made in conjunction with Billy Klüver, needs to be seen as an extension of the invention in 1954 of what the artist called 'combine paintings' – works deriving from both painting and sculpture, or perhaps from stage sets and choreography, incorporating junk materials and personal items, the imagery of consumer society, stuffed animals, and sometimes even sound effects. Seen in this light, *Oracle* is simultaneously scenery, installation, music, everyday reality, sculpture, and a stage on which the viewer can circulate bodily. Adaptable to different settings, each having its own autonomy and characteristics, these strange objects are akin to the elements of a stage set combining different art forms. Made at the height of the Pop period – though Rauschenberg was not a Pop artist – *Oracle* shows the other side of consumer culture: the things it rejects.

Although they drew some inspiration from the British movement, and from Johns and Rauschenberg, Claes Oldenburg, Roy Lichtenstein and Andy Warhol were more forceful in developing their subject matter

∧
Robert Rauschenberg
Port Arthur (Texas), 1925
Oracle
1962–65

Galvanised sheet metal,
water and sound effects
236 x 450 x 400 cm
*Gift of Mr and Mrs Pierre
Schlumberger, 1976
AM 1976-591*

>
Claes Oldenburg
Stockholm, 1929
Ghost Drum Set
1972

Canvas and polystyrene
80 x 183 x 183 cm
*Gift of the Menil Foundation in
memory of Jean de Menil, 1975*
AM 1975-64

v
Claes Oldenburg
Stockholm, 1929
Giant Ice Bag
1969–70

Vinyl and various materials
600 x 600 cm
*Purchased with help from the Scaler
Westbury Foundation, 1999*
AM 1999-7

and a popular iconography. Their imagery consisted of everyday consumer items: ice-cream cones, fizzy drinks, sausages, hamburgers, toothpaste, tinned foods, cigarettes, matchboxes, interiors, comic strips and pictures of film stars – all of which provided an instant design, and were part of a market and cultural heritage which everybody could or should be able to relate to. Pop Art played with stereotypes of all kinds and emphasised the ambiguity of art products, in that they displayed a certain anonymity but at the same time possessed the uniqueness we normally associate with works of art.

Although most American Pop artists were ironical about consumer goods, during the 1960s Oldenburg based his work on items of refuse and introduced a connotation of poverty, sometimes introducing the sordid aspects of life, the poverty of his materials gradually extending to the value of the objects themselves. For without sacrificing their humour, his kitsch, pathetic, crazy, ridiculous objects, while leaving little room for the exaltation of merchandise and creature comforts, possessed a sort of cut-price realism. In 1961 he created *The Store*, a space which he used as a workshop and a place for performances or displaying sculpture, where the works were also on sale. Made from fragments of everyday objects and plaster or papier mâché, these works had the appearance of sculptures of pictures or pictures of pictures. In their softness and *behaviour*, many of Oldenburg's sculptures, like *Giant Ice Bag* and *Ghost Drum Set*, are reminiscent of the human body in its capacity for flexibility, movement and change.

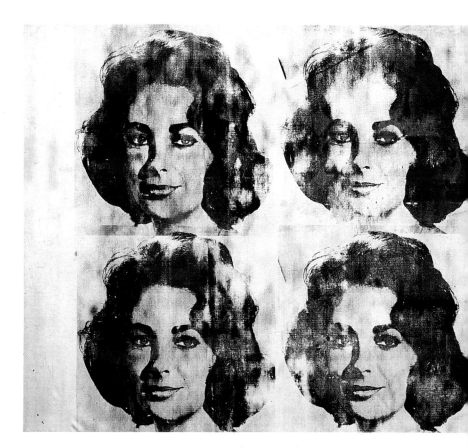

<
Roy Lichtenstein
New York, 1923
*Modular Painting
with Four Panels*
1969

Oil and magna on canvas
274 x 274 cm
*Purchased 1977
AM 1977-566*

v
Andy Warhol
Pittsburgh, 1928 –
New York, 1987
Ten Lizes
1963

Oil and lacquer screen-printed
onto canvas
201 x 564.5 cm
*Purchased 1986
AM 1986-82*

Despite their crafted appearance and disproportionate size, these objects in fact reflected contemporary American society, whose cultural artefacts were first and foremost an image of something rather than the thing itself. They were a ghostly image of the real world, as Oldenburg explained: 'The ultimate act of making things soft is the kiss of death to their functionalism and classicism. The soul of the object, one might say, ascends to heaven in ghostly guise. Its exorcised spirit returns to the realm of geometry.'

In both painting and sculpture, Pop artists aimed to achieve a real transformation of the imagery they borrowed from comic strips and art history (Roy Lichtenstein, *Modular Painting*), advertising and the cinema, the display shelves of department stores and the front pages of daily newspapers. But whatever its original quality, this imagery was always filtered by consumer society, resulting in the artists taking an ambiguous stand. We do not always know if an object is being

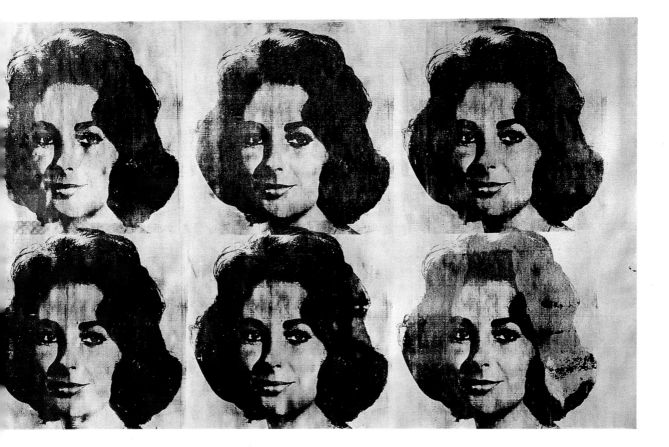

∧
George Segal
New York, 1924
Movie House
1966-67

Plaster, wood, Plexiglas,
light bulbs
259 x 376 x 370 cm
Purchased by the state, 1969
Attribution 1976
AM 1976-1018

appreciated or criticised, if a political or social situation is being glorified or denigrated, as most of their works combine an aestheticisation of reality with a questioning of the factors supposed to make life better and more beautiful. So, for instance, Andy Warhol gives the same pictorial treatment to a portrait of Liz Taylor (*Ten Lizes*) and to the *Electric Chair*. The starting point in each case is a newspaper picture, which the artist elevates to the status of Warholian image – no longer a face or a sinister object but an image hallmarked Warhol. This ambiguous position – between an aestheticised world and the world of pure banality, between the joy of consuming and the fear of being left with nothing – as well as the boredom and violence so typical of the disillusioned outlook of modern society, led some critics to refer to Pop Art as a form of 'capitalist realism'.

Also borrowing from the imagery of mass culture, the works of Edward Kienholz and George Segal, who are

^
Edward Kienholz
Fairfield, 1927 –
Sandpoint (Idaho), 1994
*While Visions of Sugar
Plums Danced in
their Heads*
1964

Various materials
180 x 360 x 270 cm
Purchased 1971
Attribution 1976
AM 1976-984

often associated with Pop Art, are striking in their 'disturbing strangeness'. Called 'tableaux' by Kienholz and 'tableaux vivants' by Segal, the common feature of their highly contrasting works is that they are generally made using plaster moulds taken from models and they include real objects from daily life. Frozen in their movements, fixed for ever in their daily gestures (Segal, *The Movie House*), despite the obvious distance established by their being sculpted in plaster, their characters are nevertheless close to us in appearance, almost human. Even though they seem to have stepped out of a nightmare, as in Kienholz's *While Visions of Sugar Plums Danced in their Heads* (a reference to an American Christmas story), their figures are akin to statuary in their form and composition, and in each case the artist tries to retranscribe the concrete, social and psychological factors of their environment, which is thereby transformed into a sort of life-size still life.

∧
Raymond Hains
Saint-Brieuc, 1926
Jacques de la Villeglé
Quimper, 1926
Ach Alma Manetro
1949

Torn posters pasted to glued
paper on canvas
58 x 256 cm
Purchased 1987
AM 1987-938

∨
Daniel Spoerri
Galati (Romania), 1930
Marché aux puces:
hommage à Giacometti
(Flea Market: Homage
to Giacometti)
1961

Chipboard, fabric, various materials
172 x 222 x 130 cm
Purchased 1976
AM 1976-261

Nouveau Réalisme was born on 27 October 1960, as a result of a founding 'declaration' only a few lines long: 'The new realists have become aware of their collective singularity. New Realism = new perceptional approaches to the real world.' This statement was signed by the artists Arman, François Dufrêne, Raymond Hains, Yves Klein, Martial Raysse, Daniel Spoerri, Jean Tinguely and Jacques de la Villeglé, together with the critic Pierre Restany, who became the group's spokesman. They were soon joined by César, Christo, Gérard Deschamps, Mimmo Rotella and Niki de Saint-Phalle. The Nouveaux Réalistes had begun producing in the mid-1950s and, for the most part, had already arrived at the individual styles and materials we associate with them – factors which, though very personal, ensured their kinship with the other artists in the group. Naturally, the individual approaches of these artists varied widely, but the imagery of consumer culture was the unifying factor and the formula 'new perceptional approaches to the real world' was an accurate summary of their procedures. It was in fact the *realism* of the objects they presented that distinguished their work from British and American Pop Art, and indeed from Figuration Narrative. Their works contained fewer images and reproductions, and more real objects. The torn posters taken from the streets by Hains and Villeglé (*Ach Alma Manetro*) could serve as an emblem of the

∧
Martial Raysse
Golfe-Juan, 1936
*Soudain l'été dernier
(Suddenly Last Summer)*
1963

Acrylic on canvas, photograph,
straw hat and face flannel
100 x 225 cm
Purchased by the state, 1968
Attribution 1976
AM 1976-1010

∨
Arman
Nice, 1928
Home, Sweet Home
1960

Gas masks in box covered
with Plexiglas
160 x 140.5 x 20.3 cm
*Purchased with the help of
the Scaler Foundation, 1986*
AM 1986-52

∨
César
Marseille, 1921 – Paris, 1998
Ricard
1962

Compression
Crushed automobile (process
directed by the artist)
153 x 73 x 65 cm
Gift of Pierre Restany, 1968
AM 1968 S

<
Jean Tinguely
Fribourg, 1925 – Berne, 1991
L'enfer, un petit début
(Hell, a Small Beginning)
1984

Various materials
370 x 920 x 700 cm
Purchased 1990
AM 1990-27

general attitude of the Nouveaux Réalistes, who used present reality and the daily environment in all its social, political, resistant, ugly or pleasant aspects, albeit recomposed, transformed or misappropriated. Their styles were not deliberately repetitive, but were attempts to operate systematically in the real world, to draw a social, economic, plastic and political map of reality using the consumer goods and products of modern society. Whether the subject matter was gas masks (Arman, *Home Sweet Home*), cars (César, *Ricard*), leisure time (Raysse, *Soudain l'été dernier / Suddenly Last Summer*), antiques and junk (Spoerri, *Le Marché aux puces / The Flea Market*), or machines so sophisticated that it was impossible to imagine their purpose (Tinguely, *L'Enfer, un petit début / Hell, a Little Beginning*), they present us with a catalogue of our lives as consumers. What we produce is what we are.

Formal Experiments and (Re)definitions of Art
1950–1975: hybrid genres

In many respects, the artistic practices of the 1950s harked back to the spirit of the avant-garde movements of the early part of the 20th century, or to certain specific works, such as the impressive collages of Matisse's final period (*La Tristesse du roi* / *Sorrows of the King*), which continued to influence many artists.

Two major trends began to emerge: one concerned with exploring the specific characteristics of the medium, to the point of calling it into question; the other mixing different media and practices. This rough categorisation applies mainly to the period from the 1950s to the 1970s, which can be described as predominantly 'formalist', in the sense that it was a time of rethinking certain questions and formulating new ones. These included the issues of frame and pedestal

<

Daniel Buren
Boulogne-sur-Seine, 1938
Cabane éclatée n° 6 :
les damiers
(Exploded Cabin no. 6:
checkerboards)
1985

Striped material and
wooden structure
283 x 424.5 x 283 cm
Purchased from the artist, 1990
AM 1990-87

>

Henri Matisse
Le Cateau-Cambrésis, 1869 –
Nice, 1954
La Tristesse du roi
(Sorrows of the King)
1952

Pieces of paper cut out and
painted in gouache, pasted
onto canvas
292 x 386 cm
Purchased by the state, 1954
Attribution 1954
AM 3279 P

(Kelly, Stella), of painting as a subject for painting (Johns), of the distinction or lack of it between sculpture and painting (Minimal Art, Rauschenberg), of where and how a work of art should be displayed (Buren), of the linguistic character of art (Conceptual Art), and of everyday objects and their elevation to the status of works of art (Warhol). This concentration on form should not be understood as a new incarnation of 'art for art's sake', but as the logical conclusion of the problems raised by the avant-garde movements, as if such formal questions regarding the component parts of a work of art must necessarily be asked. Nor did these artistic developments prevent direct political engagement, against the war in Vietnam for example (Arte Povera, Conceptual Art, Art & Language), or political involvement of an indirect but equally relevant kind, as when the Minimalist artist Donald Judd claimed that his choice of material (corrosion-resistant steel rather than

∨
François Morellet
Cholet, 1926
*Du jaune au violet
(Yellow to Violet)*
1956

Oil on canvas
110.3 x 215.8 cm
Purchased 1982
AM 1982-15

^
Frank Stella
Malden, 1936
*Mas o menos
(More or Less)*
1964

Metallic powder and
acrylic on canvas
300 x 418 cm
*Purchased with help from
the Scaler Foundation, 1983*
AM 1983-95

marble) had political and social implications. Similarly, the human figure continued to be a powerful theme, leading to rewarding developments in both painting and sculpture, as evidenced by the works of Jean Dubuffet, Willem de Kooning and Georg Baselitz. But the once well-established boundaries between figuration and abstraction became blurred, as artists embarked on a complete rethink of their duality or complementarity. In the final analysis, even though some questions were entirely limited to a particular medium – and painting and sculpture returned in force in the 1970s – the themes and genres associated with abstraction, figuration and the object were gradually and deliberately merged as the result of a lack of differentiation between techniques and processes. Hybridisation was the order of the day.

∧
Donald Judd
Excelsior Spring (Missouri), 1928 –
New York, 1994
Untitled
1965

Tinted Plexiglas, 4 steel wire-strainers
51 x 122 x 86.2 cm
Purchased 1987
AM 1987-939

<
Carl Andre
Quincy (Massachusetts), 1935
144 Tin Square

Assemblage: 144 squares of tin laid
out in rows of 12
367 x 367 cm
Purchased 1987
AM 1987-1137

<
Dan Flavin
New York, 1933 – 1996
Untitled (To Donna 5a)
1971

Fluorescent tubes, painted metal
245 x 245 x 139 cm
Gift of Leo Castelli by way of the Georges Pompidou
Art and Culture Foundation, 1977
AM 1977-210

In the space of just a few years, from the mid-1950s to the early 1960s, a new generation of abstract painters undertook a radical re-examination of the components of colour, format, support, technique, and the relationship between the viewer's perception and the work being viewed. The aim might be to reduce the subjective intervention of the artist and the content of the work to a minimum while playing on purely visual effects (Morellet, *Du jaune au violet / Yellow to Violet*), or to cut out the stretcher in such a way that the artist had only to reproduce, as if by deduction, the external form conditioning what was inside the painting, which might not correspond – again by an optical illusion – to the cut-out in question (*Mas o menos*, Frank Stella). The rigour of this artist's work, and the problem he first

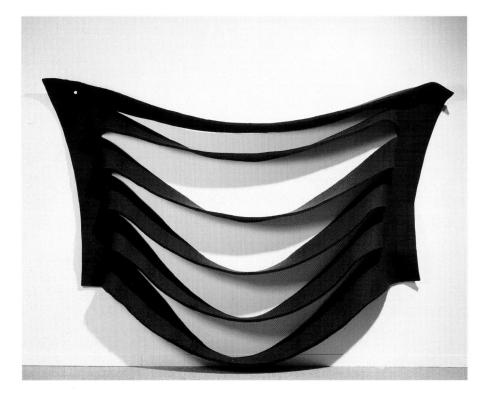

^
Robert Morris
Kansas City, 1931
Wall Hanging (Felt Piece)
1969–70

Felt
250 x 372 x 30 cm
Gift of Daniel Cordier, 1989
AM 1989-458

>
Sol LeWitt
Hartford, 1928
5 Part Piece (Open Cubes)
in Form of a Cross
1966–69

Dripped lacquer, painted steel
160 x 450 x 450 cm
Purchased 1976
Attribution 1977
AM 1977-108

raised in 1960 (at the same time as Ellsworth Kelly or Kenneth Noland), as to the redefinition of a cut-out object which is neither painting nor sculpture, paralleled the concerns of the artists who initiated the Minimalist movement in 1965: Carl Andre (*144 Tin Square*), Dan Flavin (*Untitled*), Donald Judd (*Untitled*), Sol LeWitt (*5 Part Piece*) and Robert Morris (*Wall Hanging*).

Despite its name, Minimal Art was not an aesthetic reduced to the forms of objects alone. Although all these artists worked on geometrical figures that could be derived one from another (square, rectangle, triangle, etc.), on developing variations of predetermined structures, on problems of volume, surface and flatness, it would be wrong to jump to the conclusion that these forms reduced to their simplest expression would

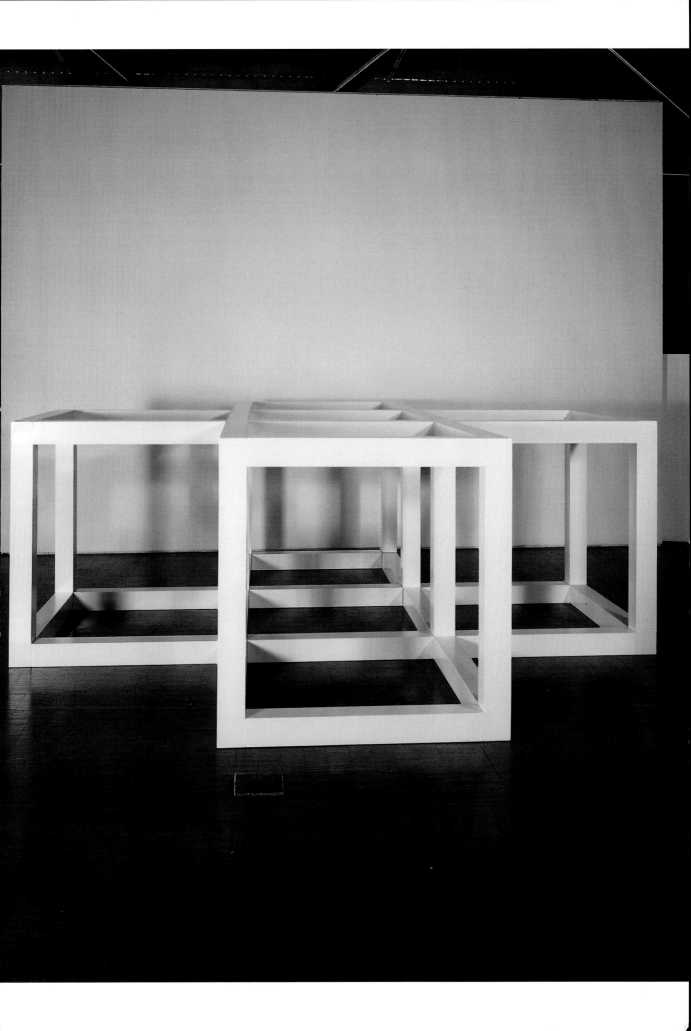

necessarily lead to an emphasis on the minimal or the negative. The aim of the Minimalists was, on the one hand, to escape from the age-old categorisation of painting/sculpture and, on the other, to question the very status of art. Without constituting a movement or producing a manifesto, they nevertheless shared a desire to work on a human scale with simple geometrical forms made of contemporary materials which were not illusory,

>
Brice Marden
Bronxville (N.Y.), 1938
Thira
1979–80

Oil and wax on canvas
244 x 460 cm
*Gift of the Georges Pompidou
Art and Culture Foundation, in
honour of Pontus Hulten, 1983
AM 1983-190*

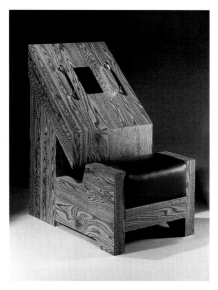

<<
Richard Artschwager
Washington, 1923
Book III
(Laocoon)
1981

Formica, metal handles,
Leatherette cushion
122 x 71 x 104 cm
Purchased 1984
AM 1984-812

<
Richard Serra
San Francisco, 1939
5 : 30

Corten steel
139 x 230 x 200 cm
Purchased 1983
AM 1983-454

<
Robert Ryman
Nashville (Tennessee), 1930
Untitled
1974

Paint dripped onto canvas
pasted to wood
182 x 546 cm
Purchased 1985
AM 1985-19

or representative objects which were perceived for their own sake and which, in the words of Morris, were real objects in a real space. To the then dominant trend in art, led by Clement Greenberg, who demanded that the specificity of each medium be clearly defined, Donald Judd, acting as the spokesman of the Minimalists, replied in his 1965 treatise *Of Some Specific Objects*: 'Half, or perhaps more, of the best works produced in recent years belong neither to painting nor to sculpture . . . Nowadays, painting and sculpture are no longer so neutral, no longer simple "containers"; they are better defined and are neither incontestable nor inevitable. After all, there are specific, well-defined forms which produce relatively precise effects.' It was therefore in the context of an aesthetic battle for a hybrid art form mixing influences and issues which seemed theoretically impossible (because they were regarded as undesirable by some of the rigorist critics of the time) that other artists – artists very different in outlook from the originators of Minimal Art, such as Richard Artschwager (*Book III*), Richard Serra (*5 : 30*), Robert Ryman (*Untitled*) and Brice Marden (*Thyra*) – were able to flourish and take up and pursue questions old and new relating to 'painting' and 'sculpture'.

∧
∧
Lawrence Weiner
New York, 1942
STONES + STONES 2 + 2 = 4
January 1987

AM 1988-959

∧
Joseph Kosuth
Toledo (Ohio), 1945
One and Three Chairs
1965

Wood and photographs
200 x 271 x 44 cm
Purchased by the state, 1974
Attribution 1976
AM 1976-987

Also resistant to traditional categories, the Conceptual artists developed a quite different approach, based on the linguistic character of the work of art. The American brand of Conceptual Art, first promoted in 1965 by the publisher Seth Siegelaub, was supported by the artists Robert Barry, Douglas Huebler, Joseph Kosuth and Lawrence Weiner. An English group, Art & Language, founded in 1968, included Terry Atkinson, David Bainbridge, Michael Baldwin and Harold Hurrell. The essential characteristics of Conceptual Art were a refusal to accept art as object-orientated (and the modernist consequences of this concept: materiality, creation of the work by the artist, exhibitions, the critic as expert) and an emphasis on the idea that gave rise to the work. It did not matter whether the work eventually took a physical form or not – for instance *Stones + Stones* by Lawrence Weiner, which could not be realised – whether it remained at the idea stage or left traces of its ephemeral existence in the form of photographs, catalogues, postcards or graph paper. Joseph Kosuth's *One and Three Chairs* is part of a series entitled *Proto-investigations*, in which the artist took an everyday object and placed on either side of it a photograph of the object and its dictionary definition. This way of working was deliberately 'tautological', so that the viewer did not need to use modes of reasoning and perception other than those provided by the actual experience. The viewer understands that the definition may apply as much to the photograph as to the concrete object, or may be a general definition of any chair, i.e. of the idea behind the object. However, the photograph is not the chair (but an image), while the concrete chair corresponds to the definition but is not the whole definition, which is itself an image, as it is an enlarged photograph of the relevant page of the dictionary. There are therefore several possible interactions between images, concrete objects and ideas, and these are the internal components of the work which is submitted to us as a proposal, a definition of itself.

Although the term formalism is not appropriate to the very different works of Daniel Buren, Niele Toroni, Claude Viallat and Claude Rutault, their common concern has been to redefine the constituent parts of their work using a number of basic parameters which were virtually set in stone once the procedures had been

Niele Toroni
Muralto (Switzerland), 1937
Coups de pinceau
(Brushstrokes)
1966

Glycerophytalic paint on free-
hanging canvas
198.5 x 195.5 cm
Purchased 1990
AM 1990-324

established. For instance, since 1967 Daniel Buren has been systematically using 'alternating white and coloured stripes each 8.7 cm wide', providing what he calls a 'visual tool' for laying bare what is at issue in a work of art and in artistic intervention. The artist and his work are never neutral or autonomous, as they are always taken from the social and political fabric and submitted to financial, architectural or urban constraints, i.e. to a definite place and context. Therefore, when Buren repaints his stripes, or arranges and applies them in different settings (museums, streets, buildings, trains, walls), his rule is never to repeat the same work, as it is created uniquely for a particular place and that place alone – what he calls a work *in situ*. This rule also applies to his series of *Cabins* (*Cabane éclatée n° 6* / *Exploded Cabin no. 6*), which, even though they can be reconstructed, are never reconstructed in exactly the same way.

^
Claude Viallat
Nîmes, 1936
Untitled
1966

Impressions on canvas
214 x 257 cm
Purchased 1983
AM 1983-469

In 1967, Niele Toroni developed his particular process, which still consists in applying strokes of a no. 50 brush to a given surface at regular intervals of 30 cm: 'What I call "no. 50 brush mark" is a form which does not exist. I called it that because it is the result of a painting exercise: applying the bristles of the brush, the part used for painting, to the given surface, so that the colour is deposited on it and becomes visible' (*Coups de pinceau / Brushstrokes*). The supports may change (waxed cloth, paper, a wall), but the procedure remains the same, creating a repetition which is in a kind of dialectic tension with the difference. Toroni's work is also concerned with development over time, because, in reiterating his gesture without ever doing the same thing twice, he is recording his own temporality.

∧

Claude Rutault
Trois-Moutiers, 1941
Toiles à l'unité, 1973/
Légendes, 1985
(Canvases in Unity, 1973 /
Captions, 1985)
1973-85

6 standard canvases on
stretchers, painted the
same colour as the wall
Purchased 1988
AM 1988-1063

In 1966, Claude Viallat began using the form – a sort of bean or palette, *Untitled* – we still find in his recent works. As a result of the neutrality born of his persistence, with this form he has developed a practice which reconsiders the act of painting and the plastic constituents of the canvas – now separated from the stretcher – as well as questions of colour, format, the impregnation of the pigment, and the flexibility of the fabrics he uses, whether tarpaulins, parasols or items of clothing. Repeated on all kinds of textile support, but always different, these strange motifs are used to reveal some of the minimal characteristics of painting.

Rutault's procedure, first adopted in 1973 and still developing, is also a matter of redefining the role of some of the simple but necessary elements of painting: canvas, stretcher and monochrome. To determine the principles of the act of painting, and of the place and context in which he exhibits, Rutault drafted a series of 'definitions/methods', each enunciating a rule. Here for instance is 'definition/method no. 1', dating from 1973: 'A canvas fixed on a stretcher and painted in the same colour as the wall on which it is hung. All the standard formats available in the trade may be used, whether rectangular, round or oval. They are hung in traditional manner.' From this first rule, Rutault formulated others, each new definition/method being both a completely new development and an elaboration of older definitions/methods (*Toiles à l'unité, 1973, Légendes / Canvases in Unity, 1973, Captions*).

In the mid-1960s, a new generation of German painters who were later described as Neo-Expressionists (the group included Georg Baselitz, Jörg Immendorf, Anselm Kieffer, Markus Lüpertz, A.R. Penck and Sigmar Polke) caused something of an upheaval in the artistic landscape, then dominated by American trends (Pop, Minimal, Conceptual). Their technique was deliberately crude and violent, and their choice of subject matter was dominated by the human figure. Not until 1969 did Baselitz begin inverting his canvases, turning people and things upside down as a way of denying content and drawing attention to the purely pictorial aspects of his work. The subjects he chose were very ordinary, without any special qualities or implications.

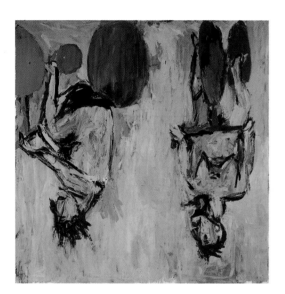

^
Georg Baselitz
Deutschbaselitz, 1938
Die Mädchen von Olmo II
(The Olmo II Girls)
1981

Oil on canvas
250 x 249 cm
Purchased 1982
AM 1982-19

>
Gerhard Richter
Dresden, 1932
Chinon no. 645
1987

Oil on canvas
200 x 320 cm
Purchased 1988
AM 1988-593

>
Gerhard Richter
Dresden, 1932
1024 Farben N. 350/3
(1024 Colours No. 350/3)
1973

Lacquer on canvas
254 x 478 cm
Gift of the artist, 1984
AM 1984-285

The fact of painting being in his eyes more important than the motif represented, he set out to forget the motif and make a picture – nothing else. By inverting his pictures, Baselitz was not trying to achieve the effect of an abstract painting, nor even tending towards an abstraction of the motif. The inverted figure was still a figure. What was disturbing was the physical shock conveyed by the artist, who played down any kind of empathy with the figures, reducing them to the status of motifs.

Influenced in the early 1960s by some of the formal aspects of Pop Art, Gerhard Richter soon distanced himself from the movement to work out his own methods, subjects and forms. In 1962 he began using photographic material culled from newspapers, magazines, encyclopedias and family picture albums, or images which he shot himself. He deliberately chose this material for its poor artistic qualities, adapting it to his own ends. Generally projected onto virgin canvas using an episcope, his images were greatly enlarged and pictorially reworked, borrowing from the techniques of photography. His canvases therefore have the fuzziness and movement blur we associate with photography, but are paintings in the full sense of the word (*Chinon*). However, Richter's purpose was not simply to imitate photography but, through his encounter with it, to delve more deeply into painting and to use it, paradoxically, as a photographic medium. Until the mid-1970s, Richter painted in this way or, perhaps we should say, represented images of the main painterly genres: portraits, history paintings, landscapes and still lifes. Since then, in his colour chart (*1024 Colours No. 350/3*) and *Abstract Paintings* series, he has explored the possible *images* of abstract painting – without going about it systematically – to shed a different light on *figurative* works.

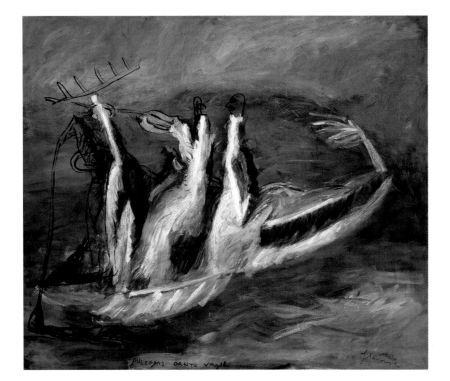

∧

Gérard Garouste
Paris, 1946
Phlegyas, Dante et Virgile
(Phlegyas, Dante
and Virgil)
1986

Oil and varnish on canvas
200 x 235 cm
Purchased 1986
AM 1986-279

Neither nostalgic nor modernist, since the 1980s Gérard Garouste has gone back almost to the origins of painting, including elements excluded and despised by abstract and figurative painting alike: narration and literary interest. A good example is *Phlegyas, Dante and Virgil*, from his *Divine Comedy* series. Though it goes against the modern formalist concept and the tendency to proclaim the death of painting, his attempt is nevertheless another way of redefining the status and ideological and plastic functions of painting, rethinking them in terms that are also formal and destructive, so as to reveal the dead end to which they lead and, paradoxically, the new possibilities they offer.

Arising, in the mid-1960s, from the interaction between painting and photography, the work of Jeff Wall draws heavily on the painting of the mid-19th century, because it was this period that gave rise to our modern pictorial conceptions and to the issues since regarded as fundamental (in particular painting as the subject of painting). Wall took one of these pictorial issues – how to be a contemporary history painter – and gave it a

contemporary slant using a different technique. Although his transparency mounted on a light box, *Picture for Women*, is an obvious reference to Manet's *Bar at the Folies-Bergère*, the important thing is not the reference as such but Wall's investigation of the status of pictures, their staging, the place of the viewer in the interplay of perceptions and viewpoints – in fact the relationship between form and content, which was all too often overlooked by an entire stream in modern painting and sculpture. This is partly why Wall chose a medium which was both different and closely bound up with the logic of the visual image.

From the 1950s to the 1970s, the emergence of Performance Art and Action Art confirmed the process of hybridisation that was taking place. From Black Mountain College's *Untitled Event* (1952) to the works of body art produced in the 1970s, the human body was featured in actions (Yves Klein) and 'happenings', for which it served as the raw material. But these activities could also result in environments (Oldenburg), videos (Nauman, Acconci) and installations. This is true of most of the works of Joseph Beuys, which are no longer

v
Jeff Wall
Vancouver, 1946
Picture for Women
1979

Cibachrome transparency, light box
161.5 x 222.5 x 28.5 cm
Purchased 1987
AM 1987-1135

<
Joseph Beuys
Krefeld, 1921 –
Düsseldorf, 1986
Plight
1985

Installation
43 felt elements, grand piano,
blackboard, thermometer
310 x 890 x 1813 cm
*Purchased with the help of
Antony d'Offay and David
Sylvester in memory of
the artist, 1989
AM 1989-545*

>
Marcel Broodthaers
Brussels, 1924 –
Cologne, 1976
*Salle blanche
(White Room)*
1975

Wood, photographs,
paint and light bulb
390 x 336 x 658 cm
*Purchased 1989
AM 1989-201*

<
Joseph Beuys
Krefeld, 1921 –
Düsseldorf, 1986
Fonds VII/2
1967/1984

Installation
8 piles of felt, metal plates,
wires and copper objects
196 x 455 x 643 cm
*Purchased 1985
AM 1985-139*

paintings or sculptures in the traditional sense, and in which he sought to embody what he described as 'social sculpture'. By this concept, Beuys was affirming that everybody could be an artist, capable of creativity. He wanted to extend the notion of art to even the most banal activities, embracing ideas and events of a social and political nature. While, through his actions, Beuys's body served as the catalyst for energies that contributed to his personal mythology, art was nevertheless intended to heal the wounds of society and its individual members. His happenings were generally wordless and only afterwards was a dialogue engaged with the audience. *Fonds VII/2*, one of a series of works entitled *Fonds*, is made of materials often used by Beuys because they retained heat and were conductors of energy: 'Stacks of felt are aggregates, and sheets of copper are conductors. The accumulation of heat in the felt functions for me like a generator, a static action. All my *Fonds* serve as a basis or foundation from which other sculptures can be produced.'

Like many artists during this hybrid period, Marcel Broodthaers blended literature, photography, films and environments, drawing inspiration from Dada and Surrealism and from Conceptual Art, to produce works of painting or sculpture while creating environments through which he raised questions about the artistic milieu. *Salle blanche* (*White Room*) is a reconstruction of the artist's home/workshop in Brussels. He described it as 'the most faithful possible reconstitution of a complex made by the artist in 1968 attacking the notions of the museum and of hierarchy.' Broodthaers in fact transformed his apartment, for one year, into an imaginary museum, which nonetheless enabled him to explore the role of the work in a public context and the material and symbolic functions of the artistic setting. The words written on the walls are now the only remaining traces of this ironic action, in which the very structure of an exhibition – the place where works of art are displayed – was called into question.

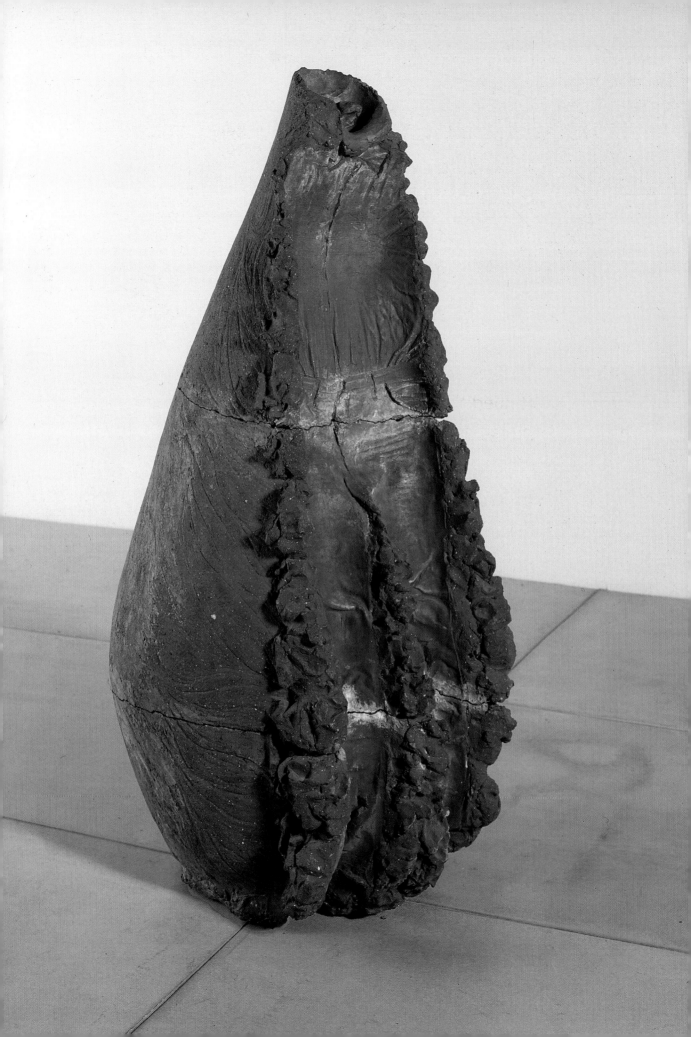

From the Perishable to the Infinite
1967–1980: Arte Povera, Process Art, installations

Widely adopted by most artists, the mixing of genres shattered the traditional categories of painting and sculpture, and even those who continued to adhere to them had inevitably to take into account the radical transformation that had occurred.

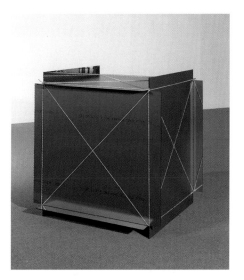

<
Giuseppe Penone
Garessio, 1947
Soffio 6
(Breath 6)
1978

Terracotta
158 x 75 x 79 cm
Purchased 1980
AM 1980-42

∧
Michelangelo Pistoletto
Biella (Italy), 1933
Metro cubo d'infinito
1965–66

Mirror and rope
120 x 120 x 120 cm
Purchased 1990
AM 1990-158

The notions of painting and sculpture were henceforth subsumed into the more open concepts of art and the artistic that led to installations, environments, happenings, processes and attitudes. It was in this context that the Arte Povera (poor art) movement emerged, in 1967. If we accept the official dates for the movement, launched by the Italian critic Germano Celant, it was relatively short-lived – 1967 to 1972 – despite its international impact. As a result of successive exhibitions, the label came to be applied to Giovanni Anselmo, Alighiero Boetti, Pier Paolo Calzolari, Luciano Fabro, Jannis Kounellis, Marisa Merz, Mario Merz, Giulio Paolini, Pino Pascali, Giuseppe Penone, Michelangelo Pistoletto and Gilberto Zorio. The term 'arte povera' was used for the first time in September 1967, by Celant, in the catalogue of an exhibition staged at the La Bertasca gallery in Genoa. Referring directly to the 'théâtre pauvre' pioneered by the Polish director Grotowski, the critic declared that: 'Gesture and mime have been born again, the language of gesture is replacing text; elementary human situations are becoming signs . . . In art, visual and plastic reality is therefore seen as it is; it is reduced to its accessories and is discovering its linguistic artifices.' Reducing things to archetypes, raising the ordinary and

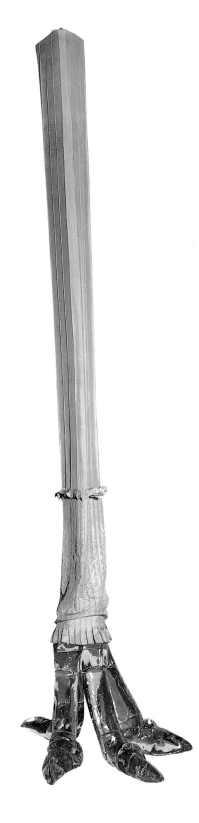

<

Luciano Fabro
Turin, 1936
Piede
(Foot)
1968–72

Murano glass and
shantung (silk)
333.5 x 108 x 79 cm
Purchased 1989
AM 1989-134

>

Mario Merz
Milan, 1925
Igloo di Giap
(Giap Igloo)
1968

Various materials
120 x 200 x 200 cm
Purchased 1982
AM 1982-334

insignificant to the status of art, giving primacy to matter and materials, to the body, to pure presence – these were some of the characteristics of Arte Povera as defined by Celant. Despite the deliberate vagueness of this manifesto, it would be wrong to conclude that 'poverty' implied simply a process of stripping away. In fact, the artists concerned often used aesthetically and intrinsically rich materials, such as mirrors (Pistoletto, *Metro cubo d'infinito*), Murano glass (Fabro, *Piede / Foot*), or marble, bronze, copper and neon lighting (Mario Merz, *Igloo di Giap / Giap Igloo*), and the materials adopted by Arte Povera were certainly no 'poorer' than those used in the collages of Picasso, Ernst, Arp and Schwitters or the 'combine paintings' of Rauschenberg, the environments of Oldenburg and Robert Morris, or the 'accumulations' of Arman. What was different about Arte Povera was the fundamental place it gave to the developmental process of the subject matter and raw materials employed. Whether these were a lettuce (Anselmo, *Untitled*), salt, coffee, plants, animals, stones,

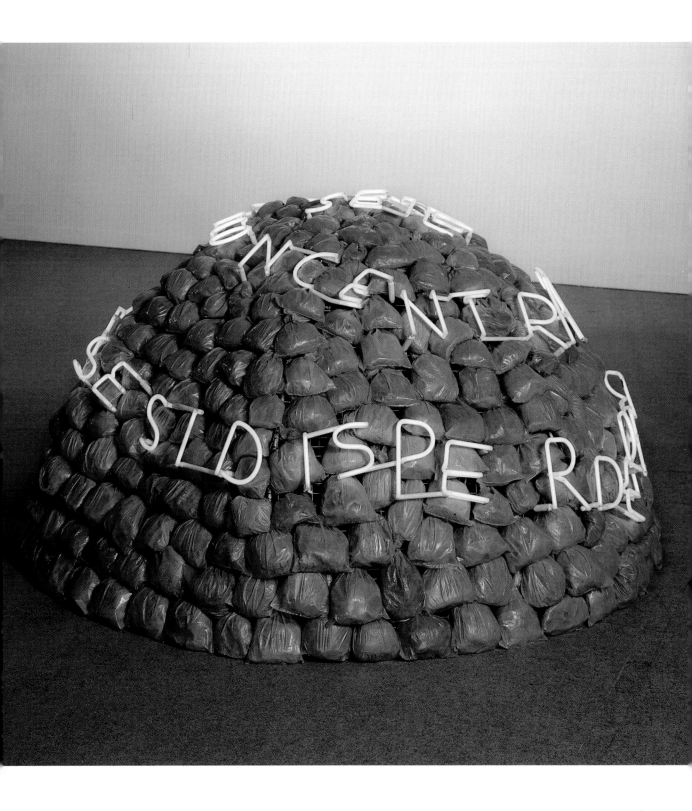

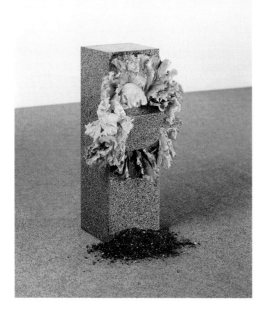

fruits or clay (Penone, *Soffio 6 / Breath 6*), wax, acids or plaster (Paolini, *Caryatid*), coal, wood or wool (Kounellis, *Untitled*), cotton, gas or rubber (Zorio, *Per purificare le parole / To Purify Words*), the emphasis was often on the ephemeral and perishable characteristics of the materials which partly or wholly constituted the work. Autonomy no longer belonged to the work of art alone but to the physical development of each natural element, often not reworked by the artist and presented in the raw state. Where aesthetics were concerned, it was not a question of returning to the state of nature, nor of playing culture off against nature, but of metaphorically – or concretely – including man (we, too, are perishable, transient beings) in the perpetually changeable process of thought. And this aesthetic thinking was concerned with matter, not with manufacturing a physically and conceptually *separate* artefact. Unlike a number of other avant-garde movements in the 1960s and 1970s, Arte Povera did not create 'artefacts', as Minimal Art, Pop Art or Nouveau Réalisme might do, but ductile, soft, malleable materials which could receive for a limited time span the no less ephemeral marks of the hand or body of the person shaping them. The role of the raw material was to retain and display the real imprint of its manufacture or transformation. This was the best way of presenting the 'poverty' of an age-old human gesture: that of transforming the world simply to ensure survival.

∧
Giovanni Anselmo
Borgofranco d'Ivrea, 1934
Untitled (granite, lettuce, copper wire)
1968

Granite, fresh lettuce, copper
70 x 23 x 37 cm
Purchased 1985
AM 1985-177

<
Giulio Paolini
Genoa, 1940
Caryatide
1980

Plaster, drawing on Canson paper
182 x 204.8 x 25.5 cm
Purchased 1981
AM 9181-29

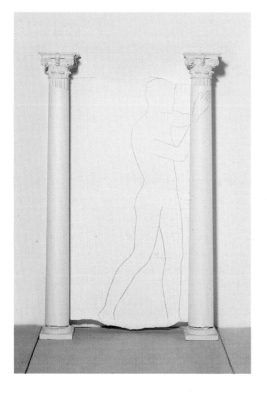

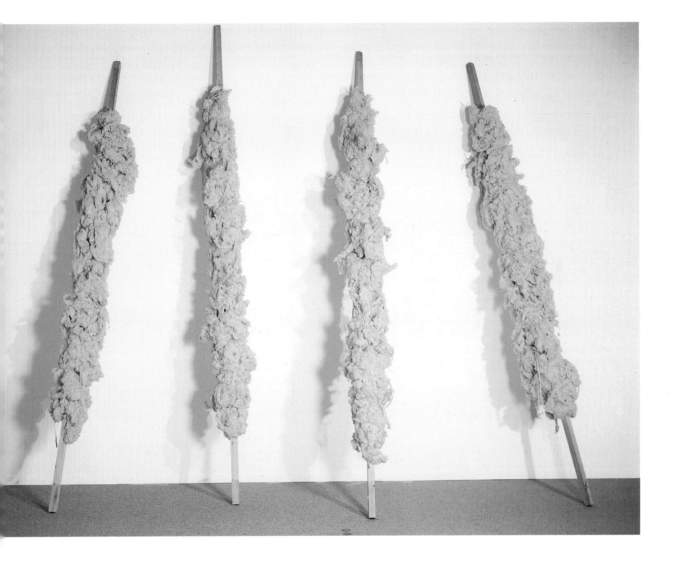

^
Jannis Kounellis
Piraeus, 1936
Untitled
1968

Installation
Raw sheep's wool,
string on wood
515 x 700 x 75 cm
Purchased 1983
AM 1983-453

A leading representative of Land Art – a tendency which emerged in the early 1970s and was dominated by British and American practitioners – Richard Long works in a natural setting, using materials found *in situ* during the many journeys he has made around the world. He assembles and arranges them in forms generally far removed from those occurring naturally, even though they are sometimes reminiscent of such natural forms. Most of these man-made arrangements are ephemeral, as the resulting works are left where they are, subject to the tender mercies of climate and weather. Photographs are the only surviving witness to Long's work. However, he does sometimes arrange

materials in galleries or museums, as in the case of *Cornwall Slate Circle*, consisting of 290 pieces of dressed slate placed in a more or less regular manner on a circle previously drawn on the ground. Constructions created in a natural setting therefore broaden the notion of raw material and of sculpture as a genre, tending to result in fleeting monuments born of the encounter between nature and culture.

Tony Cragg's work could be regarded as that of an archaeologist of modern society, since the materials he uses are essentially junk. Taking account of their colour, weight, density and form, the artist uses these discarded objects as he might use a pigment or charcoal to draw totally new forms. In *Opening Spiral*, the materials are

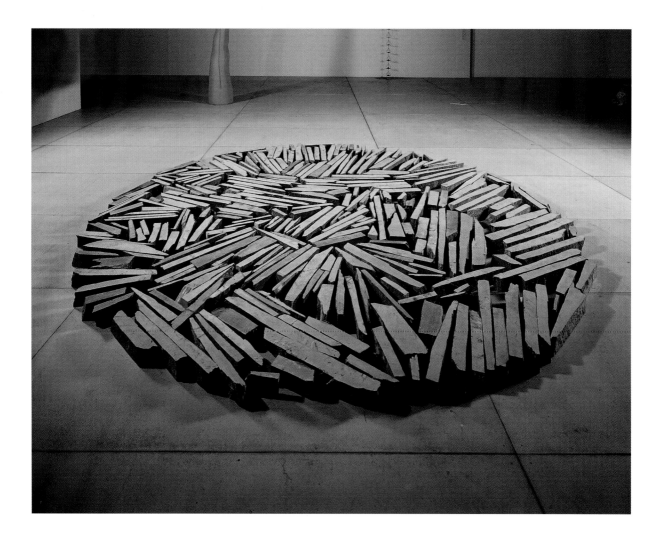

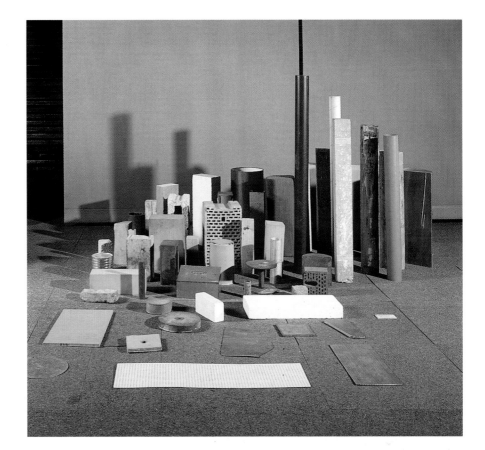

spread out on the ground, their interaction creating effects of colour and texture in such a way that by their components alone they condition the physical characteristics of the form of the object and refocus attention on their raw materiality.

In the 1970s, Barry Flanagan, another artist concerned with a renewed approach to materials, produced some fragile, fluid works which borrowed from the classic vocabulary of statuary but perverted the concept of the statue as a solid, durable object set on a pedestal to symbolise something of noble import. *Casb 1'67*, for instance (the title refers to the materials used: a canvas bag filled with sand), suggests a column, a standing portrait, or an enlarged object, but its basic properties are opposed to those of modern sculpture: soft, heavy, sagging, destructible.

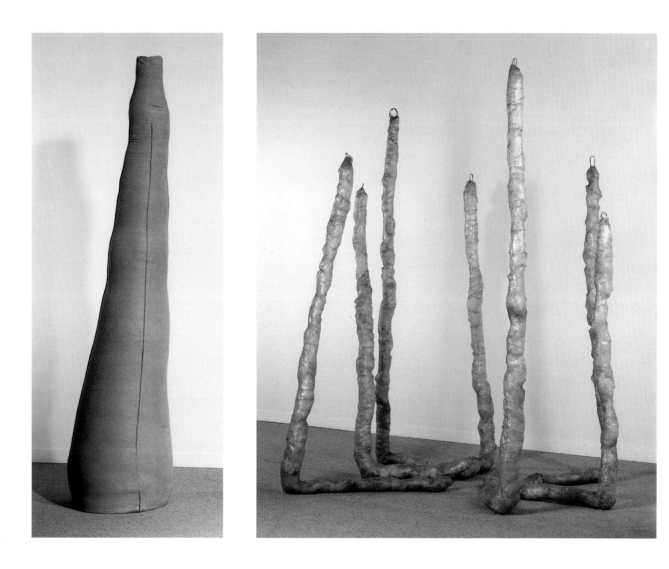

Can a work like Eva Hesse's *Seven Poles* still be described as a sculpture? It is certainly typical of the artist's formal and thematic preoccupations. These generally revolve around references to the body and to certain organic parts, which effectively prolong the tradition of human figuration. During the 1960s, she worked with materials little used by other artists (latex, polyester resin and fibreglass), concentrating on the physical effects of materials, which was unusual at the time. In this case, metal wire armatures have been wrapped in polyethylene, then covered with fibreglass soaked in resin. Though maintaining their abstract characteristics, the translucent appearance, shapes and strong physical presence of these anthropomorphic elements inevitably suggest intestines.

∧
Barry Flanagan
Prestatin (Wales), 1941
Casb 1'67
1967

Canvas and sand
260 x 60 x 60 cm
Purchased 1980
AM 1980-5266

∧
Eva Hesse
Hamburg, 1936 –
New York, 1970
Seven Poles
1970

Aluminium wires,
polyethylene,
fibreglass, resin
272 x 240 cm
Purchased 1986
AM 1986-248

^

Toni Grand
Gallargues-le-Montueux
(Gard), 1935
*Vert, équarri, équarri
plus une refente partielle,
équarri plus deux refentes
partielles*
*(Green, squared off,
squared off plus a partial
resplit, squared off plus
two partial resplits)*
1973

Tree branch
164 x 170 cm
Purchased 1983
AM 1983-368

Also concerned with the nature of materials, the work of Toni Grand in the 1970s was based on what he called a 'deconstructive reading' of sculpture. He was then using mainly wood, a material somewhat neglected by most modern and contemporary sculptors. This choice of material was also influenced by his desire to show the manufacturing process, or genesis, of the work, which is contained in its title. *Vert, équarri, équarri plus une refente partielle, équarri plus deux refentes partielles (Green, squared off, squared off plus a partial resplit, squared off plus two partial resplits)* is an account of the different operations performed by the artist on the wood, which could still evolve naturally, without human intervention. This is very much in keeping with Grand's aim, which is to allow the qualities and properties of the material to manifest themselves.

>
Vito Acconci
New York, 1940
Convertible Clam Shelter
1990

Various materials, lighting
and sound effects
150 x 240 x 280 cm each shell
*Gift of the Friends of the Musée
National d'Art Moderne, 1994*
AM 1994-262

**As well as works created in a natural context and
partly or entirely perishable works set up in a museum
or gallery, we ought to mention works which cross
into the architectural field, thereby giving a further
dimension to the notions of painting and sculpture.**
The common feature of works as different as Vito
Acconci's *Convertible Clam Shelter*, Bruce Nauman's
Dream Passage with Four Corridors, Jean-Pierre Raynaud's
Container zéro and Imi Knoebel's *Schattenraum IV*
(*Shadow Room IV*) is that they all explore spatial and
physical notions which are not sculptural in origin, or at
least which the notion of sculpture is no longer adequate
to explain, even in material terms. Ephemeral or stable,

<
Bruce Nauman
Fort Wayne (Indiana), 1941
Dream Passage
with Four Corridors
1984

Panels, fluorescent tubes,
tables, chairs
283 x 1241 x 1241 cm
Purchased 1987
AM 1987-1136

>
Jean-Pierre Raynaud
Courbevoie, 1939
Container Zéro
1988

Tiles and various materials
330 x 330 X 330 cm
Purchased with the help of
the Centre National des Arts
Plastiques, 1988
AM 1988-2(1)

>
Imi Knoebel
Dessau, 1940
Schattenraum 4
(Shadow Room 4)
1988

Hardboard, acrylic on wood
290 x 360 x 300 cm
Purchased 1990
AM 1990-363

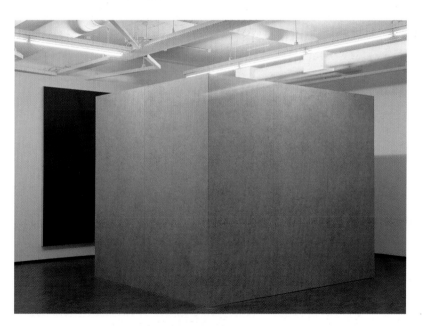

composed of natural materials or manufactured, combining artefacts with actions or forming environments, constructions in dialogue with architecture – the fact that the works of these artists (and many others) are difficult to classify into the traditional genres of painting or sculpture is because either they no longer belong there, or because the genres themselves are in need of a complete redefinition. Undoubtedly, we sense that some works have

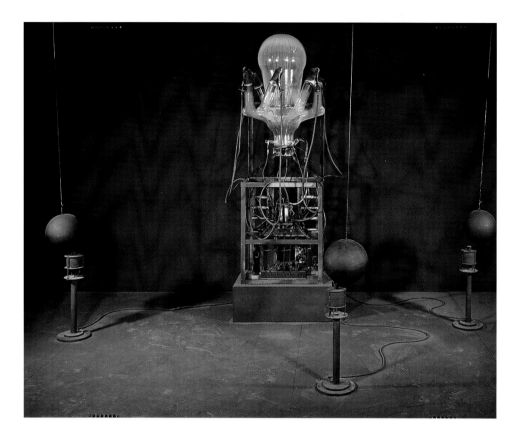

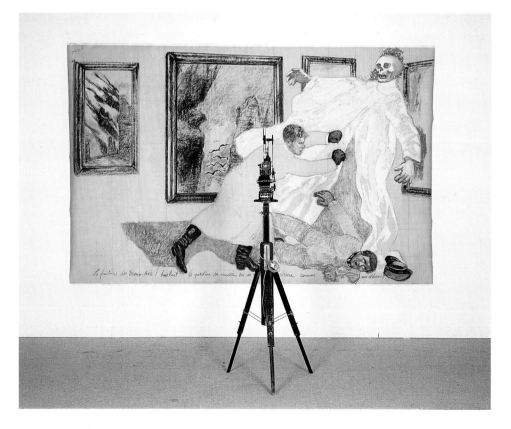

<
Takis
Athens, 1925
Méduse
(Medusa)
1980

Electromagnetic unit with
mercury-vapour lamp
220 x 60 x 40 cm
Gift of Alexandre Iolas, 1980
AM 1980-547

>
Bertrand Lavier
Châtillon-sur-Seine, 1949
Mademoiselle Gauducheau
1981

Metal cupboards painted with
acrylic paint
195 x 91.5 x 50 cm
Gift of the Friends of the Musée
National d'Art Moderne, 1987
AM 1987-634

<
Jean Le Gac
Tamaris (Gard), 1936
Story Art (with
Beaux-Arts ghost)
1986

Charcoal, pastel and casein on
paper, film projector and stand
Drawing: 250 x 340 cm
Gift of Daniel Cordier, 1989
AM 1989-426

a formal kinship with sculpture, like Takis's *Meduse*, or with furniture and painting, like Bertrand Lavier's *Mademoiselle Gauducheau,* an artefact painted entirely in acrylic. Or, like Jean Le Gac's *Story Art*, executed partly in charcoal and pastel, they may be based on the narrative tradition of painting. In such cases, the form, the position in space or the isolation of the object, the material, the technique or the way of presenting it invite us to hazard a sculptural or pictorial interpretation. But at the same time, the normal sculptural criteria are too restricted. They are often no longer an issue, since the work will for a time have consisted in distinguishing itself from or effecting a rapprochement with the aesthetic of sculpture or painting. Christian Boltanski's *Les Archives de Christian Boltanski, 1965–1988* (*The Christian Boltanski Archives, 1965–1988*), for instance, or Annette Messager's *Piques* (*Spades*) use non-sculptural or pictorial materials, and the way they are displayed is very different from traditional ways of hanging paintings. So we see that the logic of mixing the arts first introduced by the avant-garde

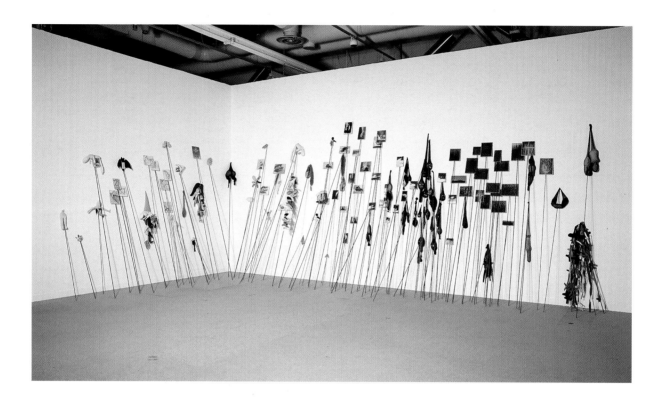

movements of the early part of the century has led to situations which at first glance seem very strange in pictorial or sculptural terms, but which are really quite simple. Where hybrid works are concerned, either they are just one more metamorphosis of painting and sculpture, or the categories no longer correspond to the artefacts they are supposed to cover, or again these artefacts are mixtures of the two plastic and historic moments. Let it be stressed that neither the absence (presumed or real) of clear criteria and conditions for defining 20th-century painting or sculpture, nor the existence (presumed or real) of works of contemporary painting or sculpture, is preventing the emergence of new formal discoveries and works rich in meaning.

^
Annette Messager
Berck-sur-Mer, 1943
Les Piques
(Spades)
1992–93

Various materials
250 x 800 x 425 cm
Purchased 1994
AM 1994-85

>
Christian Boltanski
Paris, 1944
Les Archives de C. B.,
1965-1988
(The C. B. Archives,
1965-1988)
1989

Metal, photographs, printed
matter, lights, electrical wiring
270 x 693 x 35.5 cm
Purchased 1989
AM 1989-551

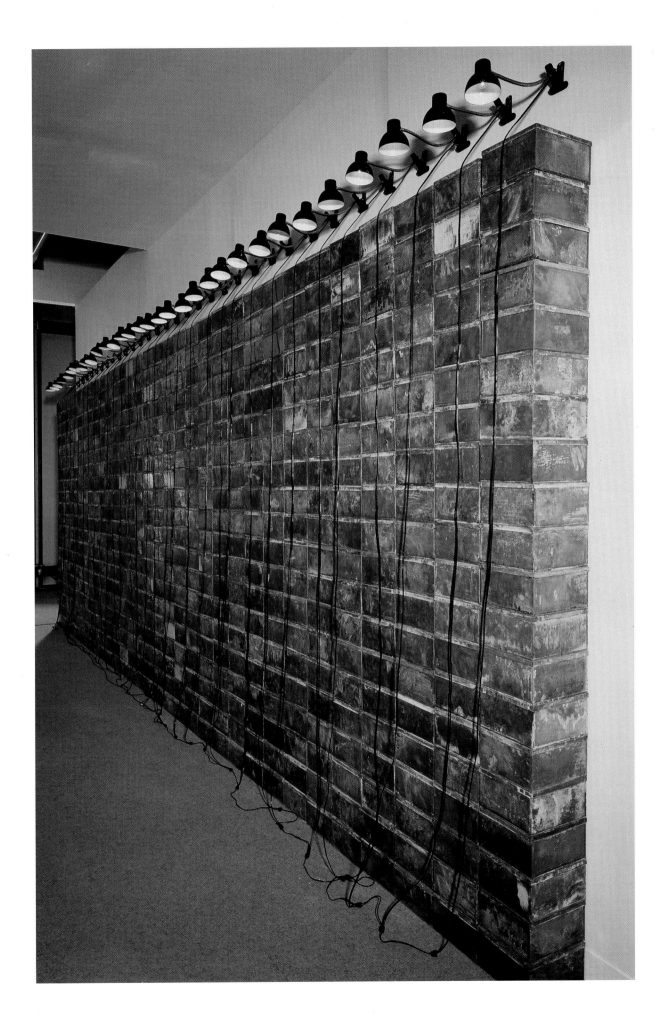

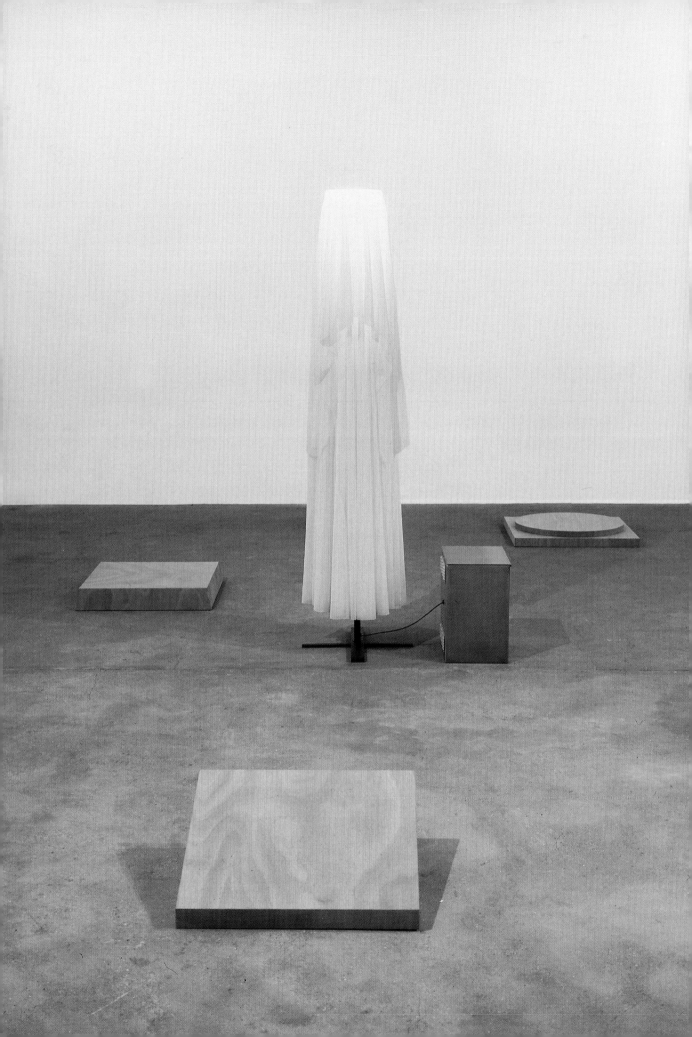

Back to the Future, Again and Again
The last decade

Since the 1980s, it is not so much new techniques (video, computer generated images) or the perfecting of existing ones (photography, moving pictures) that have transformed the artistic landscape as the attitude of artists to their chosen media.

<
Sylvie Blocher
Morshwiller-le-Bas, 1953
*Déçue, la mariée se rhabilla
(Disappointed, the Bride Put
her Clothes Back on)*
1991

Plywood, electric battery, iron,
tulle, neon lighting
Purchased 1996
AM 1996-324

v
Absalon
Devohot (Israel), 1964 – Paris, 1993
*Proposition d'habitation
(Proposal for a Dwelling)*
1992

Plywood, cardboard and acrylic paint
180 x 270 x 370 cm
Purchased 1994
AM 1994-253

The latter have lost their sacrosanct materiality and most artists are no longer obsessed with their technical characteristics. This new attitude can also be ascribed, as we have seen, to the proliferation of artistic hybrids. The possible combinations are so numerous that such terms as mixed media, assemblage, installation, intervention, work *in situ* and multimedia no longer suffice to cover the material and aesthetic range of the works being produced. Factors that make them even more difficult to classify are the proliferation of unusual exhibition venues (swimming pools, hotels, churches, restaurants), and the fact that institutions themselves (museums and art centres) are sometimes the work of art, or the exhibition itself is the subject of the exhibition. Many projects are no doubt more obviously connected with recent issues, such as the question of architecture, areas for the body to move around in and the exhibition venue (Absalon, *Proposition d'habitation / Proposal for a Dwelling*; Michel Verjux, *Petite et grande porte / Small and Large Door*), or challenges to the act of painting involving copying or quotation, a renewal of perception, or a questioning of the status of the image or picture (John Armleder, *Untitled*; Eric Fischl, *Strange Place to Park no. 2*; Bernard Frize, *Sans titre [squelette] / Untitled [skeleton]*). Some artists have taken an archaeological interest in the notion of the pedestal and the artefact itself (Didier Vermeiren, *Untitled*), or have reconsidered the human body in a sculptural transposition of movement (Marie-Ange Guilleminot,

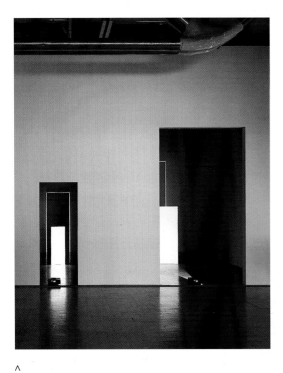

∧

Michel Verjux
Chalon-sur-Saône, 1956
Petite et grande porte
(Small and Large Door)
1984

2 slide projectors, 2 rectangular
wooden structures painted white
Variable dimensions
Gift of the Friends of the Musée
National d'Art Moderne, 1992
AM 1992-374

∧∧

John Armleder
Geneva, 1948
Untitled
1987

Installation
Oil on canvas and divan
Canvas: 100 x 100 cm
Divan: 69 x 163 cm
Purchased 1988
AM 1988-1062

>

Eric Fischl
New York, 1948
Strange Place to Park no. 2
1992

Oil on canvas
219 x 249.5 cm
Loan from the Fonds National d'Art
Contemporain, 1994
AM 1994-dép. 151

La Rotateuse / Rotating Woman). Even Marcel Duchamp is still remembered in the half-admiring, half-critical work of Sylvie Blocher, *Déçue, la mariée se rhabilla* (*Disappointed, the Bride Put her Clothes Back on*) – a reference to Duchamp's *La mariée mise à nu par ses célibataires, même* (*The Bride Stripped Bare by her Bachelors, Even*) and proof of the link which still exists between some contemporary artists and the historical avant-garde movements.

^

Bernard Frize
Saint-Mandé, 1954
Sans titre (squelette)
Untitled (Skeleton)
1990

Acrylic and resin on canvas
65 x 54 cm
Purchased 1990
AM 1990-242

Of course, even if fewer are being produced internationally, significant works of painting and sculpture, in the traditionally accepted sense of the term, are still appearing, refusing to allow themselves to be left behind formally and aesthetically by the multimedia genres. Moreover, it is a striking fact that most of them take their place, intentionally or from contextual necessity, in the tradition of historical developments we associate with painting and sculpture. However, the explosion in the production of virtual and synthetic images, and the creation and circulation on the Web of cultural information and artworks on an unprecedented scale, constitute a conceptual and material revolution – and this is not an overstatement – as to what may be regarded as a 'work of art' and, even more so, a work of 'sculpture' or 'painting'. If our rapid review of the last century shows, in the final analysis, that the regular questioning of the notions of painting and sculpture have considerably extended their range, one might justifiably expect that this cycle would be repeated as a result of the introduction of new technologies. Thus multimedia works would, in the first instance, be set against traditional materials (or older technologies), and would gradually be integrated into a period of art history, which would in turn be reconsidered and transformed in the light of fresh technological and artistic inputs. However, there is a danger here (one which has tempted a number of art historians and critics) of seeing these 'repetitions' – identifiable given adequate time and detachment – as marking some sort of 'progression' in artistic matters. This idea is fiercely defended nowadays as it gains strength from the inescapable advance of technical progress, enthusiastically adopted in art, which is unlikely to go away. At this point, two major artistic tendencies seem to be emerging. On the one hand, there are those for whom the 'material', be it highly sophisticated or a straightforward piece of iron or a pigment, continues to condition the work, to some extent at least, but without the work being reduced to it; on the other, there are those who think that only continual new technological discoveries provide suitable material for contemporary art or the art of tomorrow. The first of these two attitudes implies a 'cumulative' effect in the history of art, that is to say it is not possible to return to certain subjects or materials without taking into account what went before, albeit eschewing

^
Didier Vermeiren
Brussels, 1951
Untitled
1987

Plaster, steel, casters
165 x 81 x 89 cm
*Gift of the Friends of the Musée
National d'Art Moderne, 1992
AM 1992-375*

∧
Marie-Ange Guilleminot
Saint-Germain-en-Laye, 1960
La Rotateuse
(The Rotator /
Rotating Woman)
1995

Resin, gum drop,
various materials
217 x 170 x 157 cm
Purchased 1996
AM 1996-321

the notion of progress. The second, by combining progress in materials and techniques, tends to identify progress in science and technology with progress in art. One cannot, of course, sum up the two tendencies as implying, on the one hand, an artistic future dependent on history or, on the other, a future developing oblivious of the present, because the distinction is never so clear cut, and the tendencies sometimes overlap. And it would be vain to speculate on the forms that 'contemporary art' will take in the years ahead. Where future developments are concerned, to use a time-honoured phrase, only time will tell.

Index

The figures in italics refer to illustrations.

Photographic credits

Photoengraving
Offset Publicité, Saint-Maur des Fossés

Printing
Imprimerie Pollina, Luçon - n° 80372-A

Dépôt légal
June 2000